The Indiscipline of Painting

Tate St Ives
8 October 2011 – 3 January 2012

Mead Gallery, Warwick Arts Centre
14 January – 10 March 2012

Contents

Foreword

The earliest works in this exhibition were made in the aftermath of Clement Greenberg's essay, 'Modernist Painting', which was first published in 1960. Greenberg was later to express his regret about the effect and influence of his essay, which fostered the view that the self-reflexive language of abstract painting could only lead to an exhaustion of its possibilities and the death of the medium.

The Indiscipline of Painting asserts a different historical trajectory for abstract painting. It shows that the languages of abstraction have remained urgent, relevant and critical, revisited and reinvented by subsequent generations of artists over the last fifty years, and that they continue to provoke contemporary practitioners into dialogue. Far from being solely formal preoccupations, abstract paintings are connected to the world that they inhabit, addressing architecture, interrogating design and reviewing their own history.

For both Tate St Ives and the University of Warwick, this dialogue is of particular interest. For Tate St Ives, it allows the institution to reframe readings of the abstract paintings that were made by a small, international colony of artists in the middle years of the twentieth century, charting a parallel trajectory that sits alongside the legacies of British constructionist and abstract expressionist practices. For the University of Warwick, it presents the opportunity to relate its collection of abstract paintings from both St Ives and from North America to a strand of art practice that resonates with the institution's continued commissioning and purchase of abstract paintings for the built environment of the campus.

One of these purchases was a painting by the artist Daniel Sturgis. He conceived this exhibition and has led the selection of works. The curation of the exhibition is particular. We have been concerned to find works that may not be the usual examples of an artist's practice but which respond directly to our enquiry and to Daniel's own sensibility as a painter. In this way the show must be seen—to use Daniel's own words—as both 'partial and partisan'. It does, however, present an extraordinary group of artists and works, whose coming together is the result of many enjoyable hours of discussion, deliberation, argument and agreement.

We would like to thank all the lenders to this exhibition who have so generously espoused our vision. In addition to those lenders who wish to remain anonymous we would like to thank: 303 Gallery, New York; John M Armleder; Art:Concept, Paris; Atli Foundation; Francis Baudevin; Sascha S. Bauer; Hilary Cooper; Ingrid Calame; Campoli Presti, London/Paris; Keith Coventry; Michael Craig-Martin; Karin Davie; The Estate of Gene Davis and the Smithsonian Institution, Washington DC for their assistance in the recreation of *Franklin's Footpath*; Elizabeth Dee, New York; FRAC Auvergne; FRAC Limousin; Frith Street Gallery, London; Bernard Frize; Galerie Daniel Templon, Paris; greengrassi, London; Katharina Grosse; Hales Gallery, London; Jane Harris; Collection Haus Konstruktiv, Zürich; Hauser and Wirth, Zürich; Tim Head; Mary Heilmann; James Cohen Gallery, New York; Jacob Kassay; Richard Kirwan; Kunstmuseum Bonn; Kunstmuseum St.Gallen; Museum Kunst Palast, Düsseldorf; Museum Wiesbaden; Carl Ostendarp; Postmasters Gallery, New York; Rocket Gallery, London; Rolf Ricke; Forum für Internationale Kunst, Aachen; Kenny Schachter; B.Z. and Michael Schwartz; Jonathan Stephenson; Richard Saltoun, London; Simon Lee Gallery, London; Daniel Sturgis; The Andy Warhol Foundation for the Visual Arts; The Andy Warhol Museum, Pittsburgh; The Estate of Bob Law; The Froehlich Collection, Stuttgart; The Mondstudio Collection; The Saatchi Gallery, London and The Whitney Museum of American Art, New York.

Many artists have also contributed not only their paintings but their own ideas and experience to the development of the show. In particular, we would like to thank Michael Craig-Martin for agreeing to remake a work of his especially for this exhibition, and Francis Baudevin, Keith Coventry and Katharina Grosse, each of whom has made new work for the show. We are grateful to John M Armleder for accepting the invitation to stage a one person exhibition at the Newlyn Art Gallery as part of the exhibition when it is in Cornwall; James Green, Blair Todd and the team at Newlyn Art Gallery have worked closely with Daniel Sturgis and the artist to realise this extraordinary corresponding project. We would also like to

thank the writers Alison Green, Stephen Moonie, Terry R Myers and Bob Nickas for their elegant and concise texts, which assemble so many ideas and histories in this catalogue.

Large-scale museum exhibitions like this are rare outside London. This exhibition would not have its international and historical scope without the generous support of Arts Council England. We would also like to thank The Henry Moore Foundation, IFA and Swiss Cultural Fund in Britain, who have supported the commissioning of new works, and The Goethe Institute, the University of Arts London and the University of Warwick who contributed to the costs of the symposia which accompany both presentations of the exhibition.

The exhibition has been organised as a collaborative project by staff at both institutions, we would like to thank in particular Sara Matson, Matthew McDonald and Holly Grange at Tate St Ives, and Alison Foden, Jane Morrow and Andrea Pulford at the Mead Gallery for their work on the organisation of both the exhibition and the publication. In addition we are indebted to Jill Sheridan, who undertook the phenomenal task of researching and locating hundreds of paintings with characteristic efficiency, flair and generosity. Finally, we would like to thank Daniel Sturgis, who gave us such a rich, complicated idea and has worked with us to realise it within the exhibition. The final paintings comprise a remarkable group of works that are a testament to the continuing significance of abstract painting as a site of complex and exuberant enquiry.

Sarah Shalgosky Curator, University of Warwick
Martin Clark Artistic Director, Tate St Ives
Mark Osterfield Executive Director, Tate St Ives

The Indiscipline of Painting
Daniel Sturgis

[1]
Robert Morris, 'Notes on Sculpture Part III', *Artforum*, June 1967, pp.24–292. Interestingly in the following issue's letters pages the painter Jo Baer picks this phrase up, likens it to Donald Judd's similar position and rebutts it. Jo Baer, 'Letters', *Artforum*, September 1967. It is worth pointing out though that Judd of course expressed dissatisfaction with both painting and sculpture during this period— *but* within his writing and vision was surprisingly catholic and 'messy', a quality I very much like. Donald Judd, 'Local History', 1964, in Donald Judd, *Complete Writings 1959–1975*, Halifax and New York 1975, pp.148–156.

[2]
It is important to recognise that modernist abstraction has a pre-history. For a summary see James Elkins, 'Abstraction's Sense of History: Frank Stella's "Working Space" Revisited', *American Art*, vol.7, no.1, Winter 1993, pp.28–39. Or Markus Bruderlin, *Ornament and Abstraction*, exh. cat., Foundation Beyeler, Basel 2001.

[3]
Still one of the best introductions to this period, and a book that was to prove important to artists like Judd and Morris in the mid-1960s when it was widely read in artist circles is Camilla Gray, *The Russian Experiment in Art 1863–1922*, London 1962.

Painters have always had a very particular relationship to the history of their discipline. *The Indiscipline of Painting* is about this relationship. As such this is an exhibition that is framed by my own concerns as a painter, or more particularly perhaps as an 'abstract' painter. It was conceived in the studio, and was stimulated by the same broad question that leads me to make paintings. How can an art form that is so indebted to, and informed by, its long and rich history still make a space for itself in today's world? How can this 'antique mode'—to use the American artist Robert Morris's summation of painting way back in the mid-1960s—still be credible today?[1] And how does the reflection on past art—past painting and the past debates about painting—animate the painter and lead him or her to make new works, which embrace the present whilst being enveloped in their own unique form.

As a painter one is acutely aware that abstract painting has a history, or rather a past.[2] It will forever be bound to modernism, the last century and the modern movement. Entwined with that past are ideas of progress, freedom, certainty and mastery, ideas that since the mid-1960s, and certainly today, artists have sought to question. These ideas of advancement and independence ring true whether one thinks back to the early twentieth-century ideological avant-gardes, or the later self-reflexive tradition of modernist painting. It is worth pointing out though, that there are two main strands of non-objective art within the Western tradition, and although related they are not necessarily always theoretically compatible. Many of the artists in *The Indiscipline of Painting* have found creative tensions in recognising and utilising this discordance. Through contemplating the histories of the discipline they have found opportunity and a space in which to work.

One Western tradition of abstract art is built upon a deliberate reaction against convention. Its initial avant-garde proponents, such as those artists associated with Russian constructivism, saw the medium as revolutionary and as offering a true break from a past that they wished to overcome. Abstraction was a medium that through its revolutionary and radical nature—its difference from past bourgeois, religious or aristocratic art—had an ability to influence other spheres of life and was consequently positioned by artists to be able to engage directly in the political and social struggle. It was a new type of modern expression, fully connected with social, technological and political thinking, and able to put, in the Russian artist Vladimir Tatlin's slogan, 'Art into Life!'[3] This was, of course, an artistic movement that encouraged and found a progressive zeal in a type of emancipatory inter-disciplinarity, with the forms and motifs from paintings happily being co-opted for architectural, typographic and design innovations.

The other main tradition of abstract art found value entirely in the way a work was made and how it looked 'visually', in what was called its form. This type of formalist abstraction is now most readily associated with two critics: the British Bloomsbury writer Clive Bell, writing in the early decades of the last century, and the American mid-century critic Clement Greenberg who produced a highly influential account of the rise and development of modernist painting and the primacy of American abstract expressionism. The roots from this tradition of formalism are entwined with the Russian model, but also, more importantly, with the fin de siècle idea of 'art for art's sake'—a detached critique which saw the value of art as being independent of all moral, political or social engagement.

Clement Greenberg, whose shadow over subsequent generations of artists on both sides of the Atlantic was to prove increasingly stifling, saw painting as remaining critical in a very specific and programmatic way. This was through a continual process of refinement—a process that had the potential at least to be viewed as being able to detach painting from any direct engagement with the world that surrounded it. This was a world apart, open to all, where the visual and the formal held precedence.

For Greenberg, modernist painting could be seen as detached, as it was focusing on an internal dialogue that sought to define its very character. This progressive refining, one that emphasised the unique qualities of the medium, saw painting develop through generations of artists, from Edouard Manet to Paul Cézanne and beyond, subconsciously and consciously stressing the material and visual qualities of painting itself. These qualities—or

[4]
The origins of the concept of 'material-specicifity' though championed by modernist critics and artists like Greenberg and T.S. Eliot, can in fact be traced back to Gotthold Lessing writing in the mid-eighteenth century. The German critic argued against the Roman poet Horace's dictum 'as is painting, so is poetry'. He thought the two art forms were very different, with poetry focusing on a relationship to time and painting to space. For Lessing an artwork's value related directly to its engagement with the unique characteristics of its own medium. Gotthold Ephraim Lessing, *Laocoon: An Essay on the Limits of Painting and Poetry*, 1766, trans. Edward Allen McCormick, New York 1984, p.91.

[5]
This self-critical tendency, whereby each art would reveal 'what was unique in the nature of its medium', is clearly opposed to any form of interdisciplinarity. For Greenberg, the history of modernist painting could be seen as a project that searched out and then tested the 'working norms' or 'conventions' of painting. These 'norms' Greenberg famously defined as 'flatness and the delimitation of flatness'. By stressing these attributes, painting could be seen to have abandoned the illusory space in which pictorial representation took place, and consequently embraced ever-increasing levels of abstraction.

[6]
Douglas Crimp, 'The End of Painting', *October*, no.16, Spring 1981, pp.69–86.

'norms' as Greenberg was to term them—included the flatness of the picture plane and the delimitation of that flatness through the way the paintings were made. This tradition was one that revolved around painting's distinctiveness from other artistic media and what was called its 'material-specificity'.[4] In its most extreme forms this saw painting being championed, by critics at least, for being ideologically disconnected from the social and political world. It distorted many artist's motives and left some of the American colour field painters as seeing themselves as part of a grand developmental scheme, a scheme which theoretically could reach an end, when those 'norms', particular only to painting— were finally expressed with perfect clarity and purity.[5] For some critics this endpoint, the endpoint of modernist painting, would surely come as painting reached an apogee and an impasse in minimalist works and the monochrome canvas.[6]

It is this history, and its ramifications, that is re-interpreted, (appropriated) and called into question by the artists included in *The Indiscipline of Painting*. The 'indiscipline' of the exhibition's title refers to the porous borders that current practice has re-found in the 'discipline of painting'. The charged word 'discipline', with its controlling and restraining connotations, alludes to Greenberg's modernist aesthetic,[7] an aesthetic which is now broken or has been permeated, as painting forges new conceptual partnerships and reconnects to old pre-modernist allegiances.

The Indiscipline of Painting, then, is about the way recent painters relate to this shared history. It explores the changing relationships that painters from the 1960s to the present day have had with the ideas and beliefs of modernism, modernist painting and minimalism. But it is also about the specific use of what I would call a 'graphic language' in recent abstract painting. And that significantly complicates matters. For though this graphic language is formally and theoretically linked to the traditions in twentieth-century abstraction, it is also shared with the world of commercial design and contemporary culture. How can contemporary artists make work that somehow responds to this situation? And how can they do so *in painting*—within the constraints of a medium that can now, perhaps, seem too dated, too retinal, too formal, and forever tied to an ideology that once promulgated its own self-assured status. Not to mention a market that panders to the fleeting trends and fashions of the day? Indeed, today, does the genre that we might call abstract painting still really exist at all? For is there not a real sense that paintings that purportedly 'look abstract' are in part mere representations of what abstract paintings were (and stood for) in the past?

So the questions that you might hold with you when looking and thinking about these works are deceptively simple ones. How do these paintings address both the contemporary world and the history of their medium? And how does each of these artists re-write and interpret the history of their medium so that they can create a space in which to work?

I see the artworks in *The Indiscipline of Painting* as answering these questions in a variety of different ways. The questions are implied through the exhibition's installation, through the connections that the viewer can make between works, and through each of the paintings possessing what might be called multi-faceted qualities. That is, they have the ability to speak and connect meaningfully both to painting's past and to the present. The artists seem to have the capacity to absorb and connect to contemporary social and cultural contexts, as well as to reflect upon the shifting reception of the medium's historic development. As abstract art they can be seen as being tied to the twentieth century, but that reflection is entwined with ideas of how the artist sees the present in relationship to the past. The challenge the artists in this exhibition seem to face is how to make work that recognises this particular situation, and moves beyond the confines of a historical legacy. [8]

The Indiscipline of Painting is an exhibition of works by forty-nine different artists, but it is also an exhibition about connections—connections between paintings, connections that are sometimes explicit and sometimes not, connections that are at times formal and at other times bound by biography or by shared dialogues and concerns. However, the individual nature of each work

[7]

Greenberg saw 'the essence of modernism' residing 'in the use of characteristic methods' of each individual 'discipline to criticise the discipline itself, not in order to subvert it but in order to entrench more firmly in its area of competence.' Clement Greenberg, 'Modernist Painting', 1960, in *Clement Greenberg: The Collected Essays and Criticism, Volume 4, Modernism with a Vengeance 1957–1969*, ed. John O'Brien, Chicago 1993, pp.85–93.

[8]

Perhaps these paintings can be seen to have a desire to operate after what Andreas Huyssen described as 'the great divide'. They are illustrative of a type, or model, of painting where the blurred boundaries between high culture and the mass media neither prevent painting drawing meaningfully from its historical roots, nor disavow painting's relationship to broader contemporary culture. Andreas Huyssen, *After the Great Divide: Modernism, Mass Culture, Postmodernism*, Indiana 1986.

[9]

For good accounts of this tendency in respect to Stella and Warhol see Caroline A. Jones, 'Frank Stella: Executive Artist' and 'Andy Warhol's Factory: Commonism, and the Business Art Business', in *Machine in the Studio: Constructing the Postwar American Artist*, Chicago and London 1996. With respect to Palermo see Christine Mehring, *Blinky Palermo: Abstraction of an Era*, New Haven and London 2009. Regarding Gene Davis and specifically *Give Away* see Douglas Davis's contribution to Jacqueline Days Serwer, 'Give Away', in *Gene Davis: A Memorial Exhibition*, exh. cat., Smithsonian Institution, Washington 1987.

is important. It is for this reason that short essays have been commissioned focussing on a single work by each of the artists.

Even paintings that were realised as part of great series retain their identity as singular works. They are particular, specific, one-off objects that need to hold their own as such. This rings true for those artists whose practice blatantly mimics methods of serial production, be it through the executive rationale of Frank Stella's series, Andy Warhol silk-screening in his Factory, or Blinky Palermo manufacturing his cloth paintings or *Stoffbilder* works. And of course these ideas were pushed to a limit with the multiple canvases created by Gene Davis, Douglas Davis and Ed McGowan from their extraordinary Fluxus-inspired performance *Give Away* of 1969.[9] Even when artists are working in series in a less self-conscious manner, it is worth recognising that they are still perhaps tied to a way of working that has been influenced as much by modern methods of (market-orientated) production, as it has by ideas of the work possessing an inherent logic for continual development or refinement.

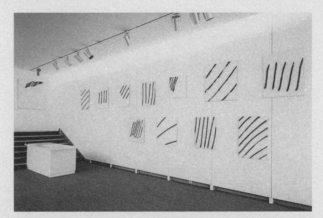

Exhibition view: *Martin Barré*. ARC Musée d'Art Moderne de la Ville de Paris, 1979.
© Estate of Martin Barre, AGDP/ DACS London 2011. Photograph: André Morain

Ironically, the importance of the singular work is also true for those artists who have sought to challenge and question it most directly. There is an element of self-sufficiency within all individual paintings, even when artists have been inspired by, and draw from, anti-painting and conceptual art strategies. This rings true where individual pieces were conceived as part of larger divergent formal installations, as for example in the work of Richard Tuttle or Martin Barré (above). It also applies to those artists who,

through reflection on the broader theoretical concerns attached to painting, work conceptually to interrogate its status—concerns such as the way paintings address issues of individual authorship, the market, the institutions of art and patronage, and the social implications of display. The artists associated with B.M.P.T. (the collective acronym used by Daniel Buren, Olivier Mosset, Michel Parmentier and Niele Toroni as they developed a collective practice in mid-1960s) could be seen to do this, as they shared each others' styles and made work that through its generic nature, focused on its installation as much as its objecthood. Though referring to painting it perhaps wasn't painting at all—as it had undermined so many of the assumed conditions that popular wisdom would see as defining painting. More recently, the artist Cheyney Thompson can be seen to quote 'painting' (the activity, the object and its reproduction) as a way to question or focus on its social and economic position in culture.

The most obvious connection between the works in *The Indiscipline of Painting* is, of course, that they demonstrate a personal selection, made at a particular time. It is as a painter that I have chosen these paintings. They all have a real pertinence for me now—not as objects for art-historical scholarship but as possessing a living, real engagement with ideas. That said, I could not have accomplished this project without the unswerving support of Martin Clark, the Artistic Director at Tate St Ives, and Sarah Shalgosky, Curator of the University of Warwick, who initially invited me to develop this exhibition. Together we navigated the terrain—a terrain, that stems from post-minimalist painting, and which, in truth, is far too vast to offer itself to

[10]
This refers to Harold Bloom's 'anxiety of influence'. Bloom argues poetic, and by extension art, history is structured by Oedipal drives. *Harold Bloom, The Anxiety of Influence: A Theory of Poetry*, Oxford 1997, p.30.

anything but a very partial and partisan study. So even if the paintings are drawn from just a few exclusive pockets of interconnected artistic activity in Europe and North America, and the selection happily disregards some well-known and wonderful works, the final group of paintings makes perfect sense for me. But this is not an exercise in self-indulgence. I also wanted to show people paintings that I am very enthusiastic about, that I find curious and wonderful and think they might not know.

Of course I am fully aware that the perspective of this exhibition is just one of many vantage points from which to view these paintings, and by framing the show around the problematic position of abstraction, other perspectives may have been lost. Indeed many (maybe all) of these works, whilst referring to abstract art, are representational or concrete or 'against' abstraction and could easily find a place in the theoretical dialogues around pop art, post-conceptual art, the gendered politics of

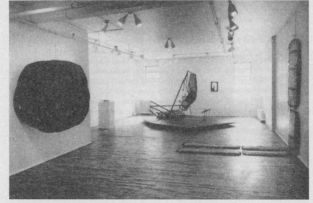

Exhibition view: *Group Show*, Green Gallery, New York 1961. Photo shows: Myron Stout's *Untitled Number 2*, 1956 (centre), flanked by from left to right, works by Claus Oldenburg, Lucas Samaras, Mark di Suvero and Oldenburg. ©Rudolph Burckhardt/DACS London 2011

'pattern and decoration', and the expanded cultural fields of painting.

Most of the artists in the exhibition are represented by just one work. Sometimes this is a signature piece, a classic work that encapsulates the artist's practice. At other times it is a more tangential work and throws light on an aspect of that artist's career that is especially interesting. Some of these paintings are in the Tate's Collection and are perhaps known to a British audience, but many others, the majority, have been gathered directly from artists and from private collections and have not been shown before in Britain.

The earliest works I have selected are two pieces by the American painter Myron Stout, an artist who is perhaps not widely known in this country. They open the exhibition. They were made in the 1950s, or rather were started in the 1950s as they took years to complete. Chronologically and geographically they would fit more happily within the boundaries of New York or American School formalism than in an exhibition charting more recent practice. But their inclusion points out an important concern that runs through the show—that the culture of painting is far broader than the merely familiar and well known, and in the contemporary situation, many artists have been inspired by a levelling of the marginal and canonical.

I see this levelling as allowing a renegotiation with past art, one that allows a more open dialogue, and which takes account of the ways culture develops and the so-called 'anxieties of influence' that play on any creative endeavour, but are perhaps felt by painters more acutely than most. [10] This creative re-negotiation demonstrates the inventive possibilities of re-reading and repositioning oneself away from too linear or didactic a form of art history. (We re-remember that the discipline of art history itself is not just a modernist invention.) Indeed this attitude emphasises that there can never be an authoratitive idea of history. Stout fits this bill. For though the work emerges from the context of abstract expressionism, these incredibly hard-won and slowly executed paintings can be seen as being more pertinently in dialogue with later artists' work. Stout found particular favour with subsequent generations of avant-garde artists, like those associated with Richard Bellamy's Green Gallery in New York in the 1960s (above).

[11]
I am thinking here of a number of intersecting trajectories. Such as: exhibitions like *High Times, Hard Times: New York Painting 1967–1975* (New York, Independent Curators, 2006) that charted the development of a type of painting in New York that expunged Greenbergain aesthetics yet remained framed within the boundaries of abstract painting; the continuing importance of artists associated with Konrad Fischer Gallery such as Blinky Palermo, Gerhard Richter, and more marginal figures like Bob Law; as well as those French and Swiss artists who comprised B.M.P.T. whose collective works, subsequent practice and legacy still inform current debate. Each of these trajectories has been recognised within this exhibition.

Aside from Myron Stout's paintings there are also examples of work by some of those near-mythic figures in post-war art, artists like Gerhard Richter, Blinky Palermo and Robert Ryman, whose on-going contribution to recent painting can never be over-emphasised, and whose influence must be negotiated by later generations of painters, as they, like them, ask what is crucial in their discipline. Yet these great artists are not necessarily to be seen as obstacles to be overcome; their presence in this exhibition points to the unfinished business within their practice. I think the selected works still speak directly to the concerns of later generations. Although Palermo's cloth paintings, or Ryman's first regulated monochromes, might have been assimilated into standard art histories, I see the problems and questions they continue to pose about how painters view the identity of paintings as still vital. Indeed both Palermo and Ryman, in very different ways, remind us to examine the beauty and materiality of painting through its unique position in a broad and competing arena of other visual and material cultures. In Palermo's case this is derived through a simple confident gesture with mass-produced dyed cloth. The resulting works, whilst referring to consumerism, domesticity and industry (of both the cloth and of course the painting), escapes too narrow a reading by connecting to the concerns of formalist abstraction—to colour, form and tactility. For Ryman this connection riffs between the rarefied sphere of monochrome painting and the concrete, actual, regulated and systematic brushstroke in a particular brand of manufactured white paint.

This exhibition also highlights a recurrent interest in the monochrome. For some artists this interest is expressed through the heightened sensitivities that the genre can offer, for others, through its pictorial and physical truth. There has been a re-investment in this supposedly finite position, which shows an expanded and far richer territory for painting than one might have readily assumed. It is one that is less confined to introspection and the restaging of a historically contested moment in painting's modernist history, than in the possibilities of sharing a formal language with the radical roots of painting, the materiality, even 'objectness' of painting,

or indeed the world of banality.

The theoretical debates of the late 1960s and 1970s stand behind many of the concerns of this exhibition. It was during this period that there was a tendency to consider abstract painting to be an isolated and redundant form of expression, either bogged down by the dominance of Greenbergian formalism, or drifting into minimalist practices. This resulted in many artists moving away from abstraction and painting altogether, in search of an art form that could more readily respond to the dramatic social, economic and political changes which characterised the era. But this reading, although true, is an oversimplification that has hidden many of the most interesting debates which took place within painting during these decades. Many artists, a number of whom are included in this exhibition, were acutely aware of the position in which painting then seemed to find itself. They hoped through their work to show other models for abstraction and to challenge the retrospective account of history that Greenberg promulgated—an account which both distorted the motivations of many of the artists he championed and left the discipline in a conundrum.[11]

One example of this might be found in the way artists began to amplify how real, lived experience, and autobiography, entered the supposedly rarefied and expunged realm of painting. It is amplification because it is done with a level of self-consciousness and it recognises that a residue of personal biography and experience is always present even in the most formalist of paintings. This can be seen in the hallucinogenic quality of Peter Young's psychedelic dot paintings, or the 'New Wave' knowing slackness of Mary Heilmann's canvases, which draw, in part, on individual responses to aspects of popular and counter culture.

The appropriation of, or representation and use of some of the tropes we associate with past abstract painting, is another strand to be considered here. What is interesting is that although we might assume such a tendency to be synonymous with a particular brand of early postmodernism, when an uncritical form of appropriation was rife within many aspects of visual culture, it is more widespread. Indeed many of the selected artists recognise

[12]

In the work of the European neo-expressionist painters, those of the Transavantgardia, and in the paintings of David Salle and Julian Schnabel, a 'bric-a-brac' aesthetic of historical sampling was visible. The critic Yve-Alain Bois, in an essay from 1987, presented this style of borrowing, collaging or using as historically irresponsible because it divorces hard-won meanings from their form. Yve-Alain Bois *et al.*, *Endgame: Reference and Simulation in Recent Painting and Sculpture*, London and New York 1987. This position is somewhat similar to Thierry de Duve's, when he forcefully rejects the nascent but retrograde postmodern painting practices. Thierry de Duve, 'Who's Afraid of Red, Yellow and Blue', *Artforum*, September 1983, pp.32–7.

[13]

Stephen Melville proposed that painting after modernism relied on the tradition being divided and displaced so as to open up a new ground for painting—a ground that might, by including other media, displace 'painting' per se. Stephen Melville et al., *As Painting: Division and Displacement*, exh. cat., Wexner Centre for the Arts, Ohio State University, Columbus, 2001. This relates to looser ideas of 'expanded painting', of which Gene Davis's *Franklin's Footpath* 1972 is an exemplar. Jacquelyn Sewer et al., *Gene Davis: A Memorial Exhibition*, exh. cat., National Museum of American Art, Washington 1987. Recent reflection on expanded painting was brought together in Rainald Schumacher, *Imagination Becomes Reality – Part 1, Expanded Paint Tools*, exh. cat., Goetz Collection Munich 2006.

and use this tendency and do so in a particular and focused way. In this way they bring out very specific critical reflections on abstract painting, modernism and the present.[12] Although the 1980s are one focus for this activity—with artists such as Peter Halley utilising the formal language of abstract painting in diagrammatic representations for contemporary-symbolic ends, or David Diao basing work on reproductions of very particular paintings and their representation in history—the drive to quote and usefully 'mis-quote' is also evident in earlier and later works. Blinky Palermo's cloth *Stoffbilder* from the late 1960s are also clearly, in part, a subversion of ideas in the then dominant form of American colour field painting. The early collective activities of the B.M.P.T. broke down and re-presented the very ingredients of what they saw constituted painting in such a way as to stress its antithesis.

Although all these paintings have been made by hand, few of them exhibit what you could call a direct and self-expressive handling of paint. They represent a different type of negotiation with material. They reflect a strand of contemporary anxiety that regards the gestural and the idea of self-expression as being in some sense contrived. Even those artists who use what we might call a 'painterly' approach to the handling of their material (sometimes in an apparently loose, lyrical and physical manner like Karin Davie or Katharina Grosse) do so in a conceptually detached, or once removed, way. The method is informed by displacement as much as by the corporeal and material. That does not mean that works do not record and trace their making—all of them do. Some exhibit great skill and dexterity, others a much more mundane or commonplace style of making. Some hold great speed within their manufacture and others slowness or even timelessness. The way that time is held in the making of a painting—and in its viewing—is something that has always fascinated me. How a work, and the handling of paint and material, can imply one reading but give way to another. How they invite you to read them quickly or slowly, and how their meanings unfold conceptually over time. How paintings can hold time or be outside of time, or indeed just out of time.

This exhibition, then, focuses on an aspect of contemporary painting practice that finds vitality in the languages painting shares with the competing visual cultures that surround us. It is perhaps painting's agility in absorbing such outside influence, and reconciling it with its past, that seems today its most unique quality. As such this is not a painting exhibition that stresses the expanded nature of the practice, if that encompasses how installations, films, or objects relate and can be seen as legitimately part of paintings lineage and culture.[13] Instead, this is an exhibition that recognises the problem of thinking of painting in a historically determined way, of thinking of paintings as being abstract or figurative, of thinking of them as separate from other art. It does so in order to show the sense and non-sense of such an approach, and like the selected artists who are investigating the material properties of painting, it does so with a confidence and staginess that allows for and demonstrates conflicting degrees of both perversity and pleasure.

The Agility of Abstraction

Terry R Myers

[1]
Maurice Denis, 'Definition of Neo-Traditionalism', 1890, reprinted in Charles Harrison and Paul Wood (eds.) with Jason Gaiger, *Art in Theory 1815–1900: An Anthology of Changing Ideas*, Oxford 1998, p.863.

[2]
Forrest Bess, quoted in Ruth Kaufmann, 'Stubborn Painting: Now and Then', in Ruth Kaufmann and Mike Metz, *Stubborn Painting: Now and Then*, exh. cat., Max Protetch Gallery, New York 1992.

[3]
Sixteen Americans included work by Jay DeFeo, Wally Hedrick, James Jarvaise, Jasper Johns, Ellsworth Kelly, Alfred Leslie, Landes Lewitin, Richard Lytle, Robert Mallary, Louise Nevelson, Robert Rauschenberg, Julius Schmidt, Richard Stankiewicz, Frank Stella, Albert Urban and Jack Youngerman.

[4]
Carl Andre, 'Preface to Stripe Painting', in Dorothy C. Miller (ed.), *Sixteen Americans*, exh. cat., The Museum of Modern Art, New York 1959, p.76.

We should remember that a picture—before being a war horse, a nude woman, or telling some other story—is essentially a flat surface covered with colours arranged in a particular pattern.
Maurice Denis [1]

My painting is tomorrow's painting. Watch and see.
Forrest Bess [2]

Frank Stella was all of twenty-three years old in 1959 when his work was included in *Sixteen Americans*, one of an intermittent series of exhibitions at the Museum of Modern Art in New York that focused on American artists.[3] It could be argued that this particular exhibition is the most well known of the series, given that other participants included Jasper Johns (the next-to-youngest at twenty-nine), Ellsworth Kelly and Robert Rauschenberg. Even with a relatively diverse selection of sixteen artists and numerous works, I can only imagine how much Stella's paintings stuck out in the galleries. Judging from the catalogue, nothing else compares to the austerity of the black-and-white reproductions of what have become his most iconic works, the so-called 'Black Paintings': for example, *Die Fahne Hoch!* and *The Marriage of Reason and Squalor*, both 1959. Even when reduced on the printed page they appear to embody the complete opposite of indiscipline, as fellow emerging minimalist Carl Andre made perfectly clear in the statement he wrote to accompany Stella's paintings in the catalogue:

Preface to Stripe Painting
Art excludes the unnecessary. Frank Stella has found it necessary to paint stripes. There is nothing else in his painting.

Frank Stella is not interested in expression or sensitivity. He is interested in the necessities of painting.

Symbols are counters passed among people. Frank Stella's painting is not symbolic. His stripes are the paths of brush on canvas. These paths lead only into painting [4]

Appearances can be deceiving and context remains key, maybe more now than ever (and maybe nowhere more than in this current exhibition), so it wouldn't be too difficult to accept that Stella was playing completely by the rules, and was on, as it were, his best behaviour. He even looks like a businessman in the photographic portrait that Hollis Frampton contributed to the MoMA catalogue: the classic Ivy League student, clean shaven and dressed more for Wall Street than Tenth Street. Despite such a performance, Stella's paintings (along with the clipped restraint of Andre's statement) refused to play nice even with his closest peers (again, in particular, Johns), not to mention the representatives from the dominating authority of abstract expressionism, represented in the MoMA show by a member of the second generation, Alfred Leslie. Leslie quite possibly took things to the point of pastiche, if not camp, in his oversized—even by AbEx standards—canvases. The nagging doubt I have about this assessment drives my interest in Leslie's work, an uncertainty that is informed by his later decision to abandon gestural abstraction for meticulous figuration, a shift that introduces the necessary complexities of what is—or has been—meant by representation in painting, and reminds me that doubt remains essential to engaging with any painting from any time. That and a willingness to jump around while paying attention, which in my opinion is the thing that ensures that *The Indiscipline of Painting* will be seen as an important if not groundbreaking exhibition.

Business suit and tie notwithstanding, Stella stands as the original bad boy of *The Indiscipline of Painting*. I've called him out because his work is near the very beginning of the chronology of this ambitious exhibition. However, given that he is represented here by a painting from a few years later than his 1959 debut, I find it especially meaningful that the earliest paintings included here are by another American painter, Myron Stout, whose works would neither have looked out of place at MoMA in 1959

[5]
Radical Painting included work by Raimund Girke, Marcia Hafif, Anders Knutsson, Joseph Marioni, Carmengloria Morales, Olivier Mosset, Phil Sims, Howard Smith, Frederic Thursz, Günter Umberg and Jerry Zeniuk.

[6]
Lilly Wei, in *Radical Painting*, exh. cat., Williams College Museum of Art, Williamstown, Mass. 1984, p.9.

[7]
Marcia Hafif, 'Beginning Again', in Richard Hertz (ed.), *Theories of Contemporary Art*, New Jersey 1985 pp.11–15, originally published in *Artforum*, September 1978.

[8]
Daniel Buren, Olivier Mosset, Michel Parmentier and Niele Toroni, statement issued as a flyer for the Salon de la Jeune Peinture, Musée d'art moderne de la Ville de Paris, 3 January 1967. English translation published in Michel Claura, 'Paris Commentary', *Studio International*, vol.177, no.907, Jan. 1969, London, p.47. Reprinted in Douglas Fogle, 'The Trouble with Painting', in Douglas Fogle (ed.), *Painting at the Edge of the World*, exh. cat., Walker Art Center, Minneapolis 2001, p.15. My description of the event is indebted to Fogle's account.

[9]
Michael Corris and Bob Nickas, 'Punishment and Decoration: Art in an Age of Militant Superficiality' 1993, reprinted in Terry R Myers (ed.), *Painting: Documents of Contemporary Art*, Whitechapel Gallery, London and Cambridge, Mass. 2011, pp.90–1. Originally published in *Artforum*, April 1993.

[10]
Hal Foster, 'Signs Taken for Wonders' (1986), reprinted in Myers 2011, p.54. Originally published in *Art in America*, vol.74, no.6, June 1986.

nor likely been shocking in the least. While Stout's paintings *Untitled, No. 2* 1956 and *Untitled (Wind Borne Egg)* 1959, merely add white to the black of Stella's 'Black Paintings' (below), they more importantly present another version of indiscipline, in this case one that embraces associations as necessary if not inevitable in painting. The necessity of associations is something that even Stella seems to have recognised from the very beginning of his career, judging at the very least from his titles, or, better yet, from the escalating components of his work (form, colour, etc.) from then to his latest extreme constructions. Stella and Stout set up what I see as the three core arguments of this exhibition: abstraction and representation cannot be separated; there is no single history of abstract painting; and abstract painting is best served in the long term by its agility.

I've borrowed the first of my three arguments from an important text I've only recently discovered, written by the critic Lilly Wei in 1984 for the catalogue for *Radical Painting*, an exhibition held at the Williams College Museum of Art in Massachusetts that included work by eleven American and European painters who were all living in New York and who had been, since the late 1970s, committed to reinvigorating abstract painting by focusing on its materials and techniques.[5] Before getting to the details of this particular moment in painting's history, this is the crux of Wei's argument:

> *All painting is abstract insofar as it represents anything; representation and abstraction cannot be separated. But all painting is also real, insofar as it is a painting, composed out*

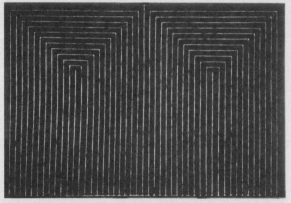

Frank Stella, *The Marriage of Reason and Squalor II*, 1959. Enamel paint on canvas, 231.1 × 337.8 cm, MoMA, New York. © 2011 Frank Stella / Artists Rights Society (ARS), New York

of its own materials: probatum est. This is the legacy of modern art. The essential question is whether or not painting still has a value. If painting continues to be valuable, indeed, to possess irreplaceable value, the search continues for where that value is located. That is the ultimate battleground; abstraction and representation are disputations about the locus of value, as is the opposition of line and color, of formalism and expressionism. [6]

Wei's assertion of value is in fact a reassertion of a point made by Marcia Hafif (opposite), one of the contributors to the exhibition, in her essay 'Beginning Again' that was published in *Artforum* in 1978. Hafif's text is thorough, laying out the terms of the situation of abstract painting at the time: 'It was not that everything had been done, but rather that the impulses to create which had functioned in the past were no longer urgent or even meaningful'; the 'four levels' on which it can be understood (its physical existence, technical factors of its making, as a historical statement, and as a form of thought); and a brisk yet comprehensive history of the recent activities and exhibitions in Europe, including Arte Povera and Support/Surface.[7] No wonder, then, that it was Olivier Mosset— the only painter included in both *Radical Painting* and *The Indiscipline of Painting*—who contacted Hafif after reading her article and suggested the idea of starting a discussion group. Mosset, as an instigator and then a 'survivor' of several so-called deaths and rebirths of painting, embodies (like Stella) in his work the value of agility as the necessary component of the

[11]
Peter Halley, 'Notes on the Paintings' (1982), reprinted in Myers, 2011, p.37.

[12]
See my 'Peter Halley at Michael Kohn', in *Art issues*, no.26, January/February 1993, p.38, in which I wrote: 'Rather than restrict the readings of these wall-like paintings to penal institutions or factories, as he has done in the past, Halley gives his recent works much more animated titles: in this show the paintings are named *Junkville*, *Keith*, and *Teen Dream*. Moving into such fashionable territory as Heavy Metal music and cult movies to give us something more accessibly upbeat and popular, these titles open up the paintings rather than lock them up and throw away the key—which no doubt seals their fate'.

[13]
See my *Mary Heilmann: Save the Last Dance for Me*, London 2007.

sustaining of painting, even if, at first glance, it comes off as the opposite.

Jumping back from 1978, it was Mosset who, along with Daniel Buren, Michel Parmentier and Niele Toroni, participated in an infamous 'refusal' of painting at the 1967 Salon de Jeune Peinture at the Musée d'Art Moderne in Paris. Working in the space, each made their signature reductive marks on a series of similarly sized canvases (red and white vertical stripes for Buren, black circles on a white ground for Mosset, horizontal bands of grey and white for Parmentier, and square blue brushmarks on a white ground for Toroni), then withdrew their work at the end of the day, leaving a sign on which was written 'Buren, Mosset, Parmentier and Toroni are not exhibiting', and distributing a flyer with a manifesto that listed the nine reasons that ended with a final proclamation: 'We are not painters'.[8]

Jumping forward from 1967 to 1993, we discover once again just how productive Mosset's agility has been. In a back-and-forth text called 'Punishment and Decoration: Art in an Age of Militant Superficiality', Michael Corris and Bob Nickas put forward yet another argument for what a Mosset painting could be:

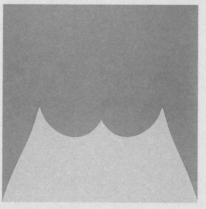

Marcia Hafif, *158*, 1968. Acrylic paint on canvas, 140 × 140 cm Collection of the artist, on loan to Mamco, Genève. © Mamco. Photograph: I. Kalkkinen

What is lacking in the semiotician's account of painting is the possibility that there might be a painting—a monochrome by Olivier Mosset, for example—that isn't a monochrome in any conventional sense, that is to say, a painting in which the opposition between figuration and abstraction has been neutralized, a kind of trompe l'oeil monochrome, a painting of a 'monochrome'.[9]

Corris and Nickas's point looks back to Hal Foster's suggestion, in his 1986 text 'Signs Taken for Wonders',

that the abstract painting emerging in the 1980s qualified 'the conventional reading of twentieth-century art in terms of simple paradigm shifts between 'representation' and 'abstraction', by becoming a *simulation* of abstraction', as found in the works of Peter Halley and Sherrie Levine.[10] Levine's *Melt Down (After Yves Klein)* 1991 literally proves Foster, Corris and Nickas's point, and Halley's *Two Cells with Conduit and Underground Chamber* 1983, in the spirit of Mosset, uses simulation to have it both ways. It's a depiction of the title's description and it's an abstract painting, or, better yet, a painting of an abstract painting, demonstrating a flexibility that at the time was usually considered to be anything but, even by the artist himself: 'Geometry is revealed by confinement'.[11]

If an abstract painting can have it both ways, or more than one way, that's hardly confinement, and there is ample evidence that Halley figured that out by the early 1990s when he started giving paintings titles like *Teen Dream*, 1992.[12] It may be that Mary Heilmann's work was an influence, and her inclusion in *The Indiscipline of Painting* is crucial. As I have argued elsewhere, Heilmann's paintings are in many ways 'replays' not only of modernist abstraction (what I've also called a picture in modernist drag, a liberating idea that could be extended to the work of, for example, Steven Parrino and Ingrid Calame), but also a rigorous yet slang translation of the rhetoric of sculpture, music, fashion, architecture, and finally painting, once again.[13] In my opinion, Heilmann is the current master of simultaneity in painting, reminding us over and over that every painting has a past, present and future that doesn't always happen one at a time or in that order. Forrest Bess's counsel about his painting—'watch and see'—could be the mantra of this exhibition and its myriad yet interconnected examples of the agility of abstract painting. It's meaningful to me that I've borrowed it from the catalogue for *Stubborn*

[14]
Stubborn Painting: Now and Then included work by Forrest Bess, Paul Feeley, Philip Guston, Mary Heilmann, Jonathan Lasker, Elizabeth Murray, Thomas Nozkowski, Philip Taaffe, Richard Tuttle and Ruth Vollmer. *There is A Light That Never Goes Out* included work by Polly Apfelbaum, Linda Daniels, Moira Dryer, Michael Jenkins, Larry Johnson, Brent Richardson, Mark Schlesinger and Philip Taaffe.

[15]
Roberta Smith, 'Abstraction: A Trend That May Be Coming Back', *New York Times*, 10 January 1992, p.28.

a modest yet influential exhibition that was organised for the Max Protetch Gallery in New York by Ruth Kaufman and Mike Metz in 1992 (Mary Heilmann and Richard Tuttle were included) at the same time that I had organised an exhibition for the Amy Lipton Gallery, also in New York, called *There Is a Light That Never Goes Out*. The latter included the work of Moira Dryer, one of several artists in *The Indiscipline of Painting* whose work was ended too soon, with her death at the age of 34.[14] Discussing both exhibitions in a review that was given the title 'Abstraction: A Trend That May Be Coming Back', Roberta Smith wrote the following:

> *A genuinely new painting movement would be a great thing right now, giving to the scene a focus and maybe even perking up the market, although it is curious that contemporary painting is forever being described as either dying or undergoing a revival. Its persistence is rarely acknowledged, even though thousands of artists pursue the medium year in and year out.* [15]

With all of its jumps and starts, connections, disconnections and reconnections, as well as its rigorous approach to indiscipline, there is little doubt (keeping in mind that painting and no doubt don't mix) that this exhibition not only acknowledges this persistence but creates more of it itself. Watch and see.

Plates

'Untitled, No.2' 1956
Oil paint on canvas
51.1 × 35.7 cm

[1]
In the lead-up to his retrospective at the Whitney Museum in 1980, with his eyesight failing badly with macular degeneration, Stout took on an assistant to complete five paintings, including *Untitled (Wind Borne Egg)*. The assistant traced the shapes onto new canvases, and Stout painted to the extent he could (he could see out the sides of his eyes, but his straight-on vision was gone). There exist two sets of these paintings—the 'unfinished' ones that are twenty years in the making, and the 'finished' ones. See Sanford Schwartz, *Unfinished Paintings*, exh. cat., Joan T. Washburn Gallery, New York 1997.

[2]
Excerpts from the *Journals of Myron Stout, 1950 to 1965*. *Myron Stout*, exh. cat., Whitney Museum of American Art, New York 1980, p.82.

It is a rare treat to see paintings by Myron Stout outside the handful of museums that have his works in their collections. In addition to being shown irregularly, there are few paintings to look at, for Stout produced very few paintings. Why? For one, Stout started 'late'. Delayed first by the Great Depression and then by serving in the Second World War, he was only able to cut loose from the teaching jobs that earned him an income and devote himself to being an artist when he was in his late thirties. After a few years of experimenting with colour and geometry, he settled into a reduced palette, simplified abstract shapes in black or white on a ground of the opposite colour, on a relatively small scale. Between 1954 and 1980, Stout made only thirteen of these paintings. *Untitled No. 2*, 1956, is the fourth painting he did; *Untitled (Wind Borne Egg)*, 1959–80, one of the last. Stout was a very slow painter. *Untitled (Wind Borne Egg)* is one of a group of paintings that took him twenty-one years to finish. It's arguable that he never really finished it, rather that he simply, and finally, let the painting be put in an exhibition.[1] It's highly possible it was too difficult to do any more of these paintings than he did.

There are paradoxes in Stout's work that are important. A work usually began as a small sketch. For the painting, the image was scaled up and then painted in with a small brush. The painting could not be finished by simply filling the shape in. The shape had to come alive, to feel as quick and impromptu as the flash of the original idea. Stout tended to concentrate on the edges on both sides of the shape, such that figure and ground gave into the whole painting. A lot of time was spent tinkering at this edge, making the painting full rather than flat. And, even though working this way took a long time, Stout did not want the time spent on the painting to be seen (although time was a huge factor in looking). He scraped paintings down when ridges developed or the paint got too thick, and if it had gone too far he started over, tracing the shape and transferring it to a new stretched canvas of the same size. The material surface had to cede to the image as much as it needed to embody it, but the paint surface of a Stout painting is thin, the brushstrokes deadpan.

The drama of painting for Stout was to make an entirely abstract painting—one that did not directly refer to anything visually recognisable—but felt true to the way the world is experienced. Stout's references were natural forms, old, even archaic, man-made things, and the human body. He wrote in a journal entry, 'The source of a curve—of "circularity"—is in one's body – not in the idea "circularity" or "curvedness".'[2] These are not signs or denotations, and not idealisations. For us Stout is a window on another world, one where different things were sought, and made possible.

Born Denton, Texas, 1908, died 1987.
Lived and worked in Provincetown, Massachusetts.

AG

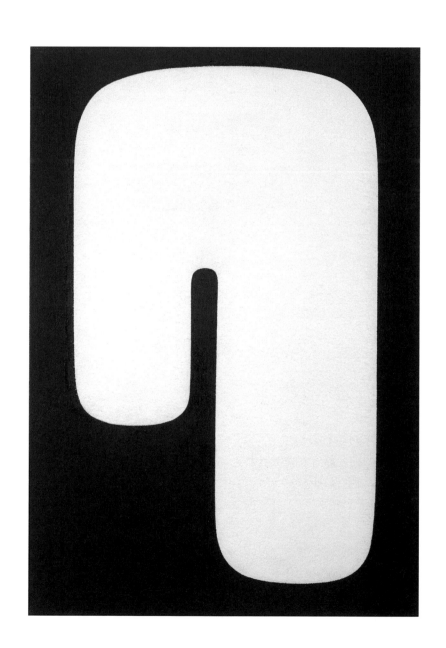

Robert Ryman

'Untitled' 1965
Oil paint on canvas
28.3 × 28.3 cm

[1]
Naomi Spector, 'Introduction', in *Robert Ryman*, exh. cat., Stedelijk Museum, Amsterdam 1974, p.9, as quoted in Robert Storr, *Robert Ryman*, exh. cat., Museum of Modern Art, New York and Tate Gallery, London 1993, p.118.

[2]
Ryman quoted. Ibid., p118.

[3]
Ibid., p.120.

The year 1965 was a minor turning point for Robert Ryman, an artist who one could say courts turning points that initiate new ways of exploring a small range of issues within painting. Gone was his habit of integrating his signature into the painting. Long gone was the use of any colour other than white. Also abandoned was the applying of paint to the canvas in an ad hoc way, the brushstrokes either filling the square canvas (always square) or not filling it, but seemingly without a plan. By contrast, paintings made in this year, and the following one, had a system. A wide brush was loaded with paint and drawn, left to right, across the top of the canvas. You can see the stroke widening as a result of Ryman bearing down as the paint was used up, the end of the stroke less precise and more unruly than the beginning. Repeat for the first middle stripe. And for the next. To fill out the remaining space, the fourth and bottom stroke was made with an even wider brush. Four brushstrokes efficiently fill the space the painting provided.

Writing in 1974, Naomi Spector noted that in this year Ryman began to work in series, and that his approach became more analytical than before. 'Now the work was about the nature of paint; the paint was the content of the paintings, as well as the form', she wrote.[1] Ryman's own explanation is less ideological: 'I wanted to see how the scale would change the painting, and how different linen or maybe a slightly different paint consistency would affect it.'[2] Describing *Mayco* 1966, a painting larger but very similar to *Untitled*, Ryman said he wanted to leave the paint alone (no 'fussing'), with no covering of mistakes.[3] He was also interested in the way light was reflected and absorbed by the paint when it had been applied in a single direction. Ryman also began, for the first time, to title his paintings. *Untitled* is one of several small paintings related to a group of larger paintings entitled 'winsors' after the brand of oil paint he used (Winsor & Newton). Ryman didn't title the smaller paintings because he wasn't planning on showing them; in fact, he only started titling works—to help identify them—when they went out to exhibitions (he began to show in group shows in 1964, and his first one-person show was in 1967).

Ryman is known as a 'critical' abstract painter, as someone interested in process and materials, and, by some, the 'last modernist painter'. We can wonder about the protocols of being a painter in a post-disciplinary era. As with a handful of other artists, with Ryman something singular runs through his enigmatic manner, the paintings themselves, as well as how and in what context they are exhibited. *Untitled* may be small and simple, but it's also eloquent and expansive, tactful and insistent, and remarkably durable as an image and an object.

Born Nashville, Tennessee, 1937.
Lives and works in New York and Pennsylvania.

AG

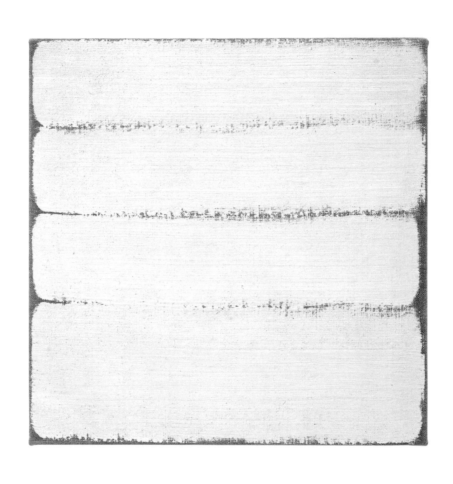

Gerhard Richter

'Two Greys Juxtaposed' 1966
'Zwei Grau Nebeneinander'
Oil paint on canvas
200.4 × 150 cm

Gerhard Richter is renowned for appropriating divergent styles of painting: in doing so, his work is situated in the space between painting, photography, and the readymade. Whereas his photo-paintings engage with the uncertain boundary between painting and photography, works such as *Two Greys Juxtaposed* may be understood as self-reflexive meditations upon the practice of painting in general. Here, Richter revisits the monochrome which is so frequent a phenomenon in the history of modern painting. Figures as divergent as Kasimir Malevich and Ad Reinhardt claimed that the monochrome enacted the 'last' painting, signifying the point at which painting can go no further. *Two Greys Juxtaposed* also bisects the canvas in a manner reminiscent of Barnett Newman's 'zips': unlike Newman, however, Richter makes no grand metaphysical claims. Instead, stripped of such grandeur, we are invited to examine the two closely valued hues as though inspecting a colour chart.

Unlike Malevich or Reinhardt, Richter avoids the severity of black and chooses instead to use grey, which is symptomatic of his practice. Grey epitomises Richter's notoriously neutral attitude: it is a non-colour, evoking little in the way of feelings or associations. Grey is also indeterminate. In line with the 'cool' pop artists of his generation, Richter claims to avoid taking an ideological stance, instead shifting the burden of meaning in the direction of the viewer. Richter's fascination with grey facilitates the interpretative ambiguity which his stubborn reticence elicits. More broadly, grey is also associated with thought ('grey matter') and, significantly, with melancholy. Influenced by Nietzsche and Adorno, Richter's philosophical pessimism is well-documented. Following this, it might be tempting to suggest that *Two Greys Juxtaposed* embodies a profound pessimism regarding painting's historical predicament, a melancholic lament for painting's lost historical primacy. However, in a manner befitting interpretative complexity, one might equally counter that the monochrome be regarded as a *tabula rasa*—a means to start afresh and reconsider one's practice. This is certainly apparent in the diversity of Richter's own work, where the monochrome is simply one approach amongst a nexus of diverse yet conceptually consistent painterly strategies.

**Born Dresden, 1933.
Lives and works in Cologne.**

SM

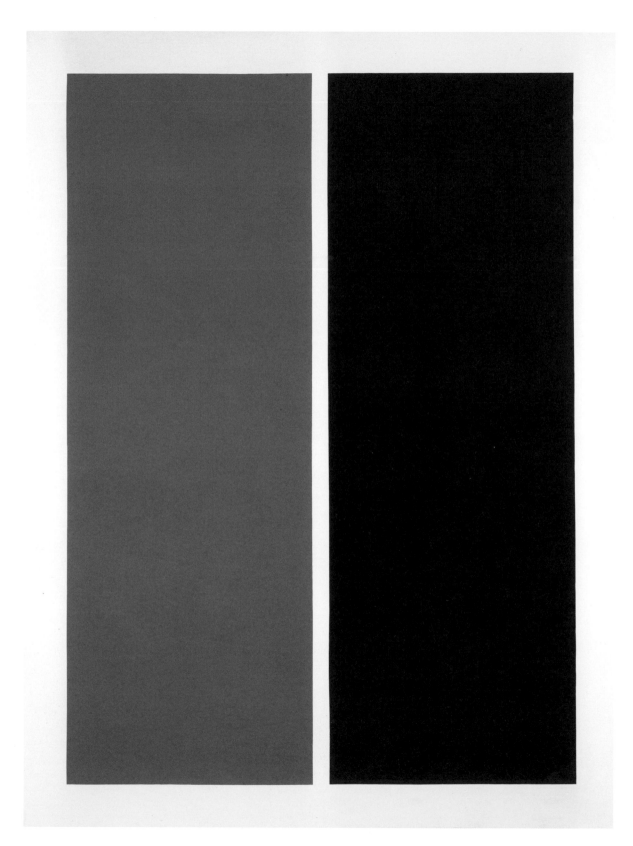

Imi Knoebel

'Black Square On Buffet' 1984
Acrylic paint on fibreboard and cardboard
215 × 165 cm

With his now-iconic *Raum 19* of 1968, Imi Knoebel introduced a unique form of assemblage, far removed from the kind with which we are familiar—the bringing together of disparate elements into a sculptural or pictorial whole—one that exists between order and disorder, and suggests nothing if not an intentional ambiguity. One wonders whether or not this work has been installed, whether we are in a gallery or a store room or the studio of the artist, or if this is indeed a work at all. Knoebel's ambitious environments, comprised of multiple parts, with panels stacked, leaning and hung on the wall, can be re-configured from one exhibition to the next, adapted to new locations, expanded or contracted as needed or desired by the artist. And so the same work may never appear exactly the same: as it finds itself in a new situation, so do viewers. Yet for all the anxiety that may be projected upon them as provisional or unstable objects, there is nothing haphazard about them. Knoebel's work is precise and in every way about composition. There may be no greater art, his sensibility reminds us, than the fine-tuning and composing of that which looks or sounds completely random, something seemingly without guile or the intervention of the artist. In the elegance of the later room-sized composition, *Genter Raum* 1990, however, one does not mistake the arrangement for that of workmen who have simply delivered various elements to the gallery. Here, everything has its specific place, or part to play.

Black Square on Buffet is a classic composition of the mid-1980s, a period in which Knoebel makes more discrete arrangements, or pared-down tableaux, as if pieces of larger works had been given an autonomy and stood on their own. There are a relatively small number of elements taking up a painterly compositional space in this work. A large fibreboard positioned against the wall supports a small fibreboard panel, a roughly taped up cardboard box, and a painted black panel leaning at the top. This is directly related to similar pieces made in 1985 and 1986 respectively, *Mein Freund* and *Mammatu*, both of which also culminate in a painted black panel. In all three tableaux, the repetition of the panel reinforces Knoebel's quotation of Kasimir Malevich and his black square, elevating the icon of painting above the humble, naked material from which it emerged. We can easily imagine the lifting of the painted panel, the last element to be installed, as a kind of performance— and just as these works can be so arranged, so too will they be undone. The appearance of these works may suggest that they are being stored (in plain view) rather being properly exhibited. This, of course, is the inescapable fate of almost every artwork in the world at any given time. If Knoebel's compositions can be seen as alive, it is because the space between their dormant and exhibited states has been attenuated and accounted for in their creation.

Born Dessau, 1940.
Lives and works in Düsseldorf.

BN

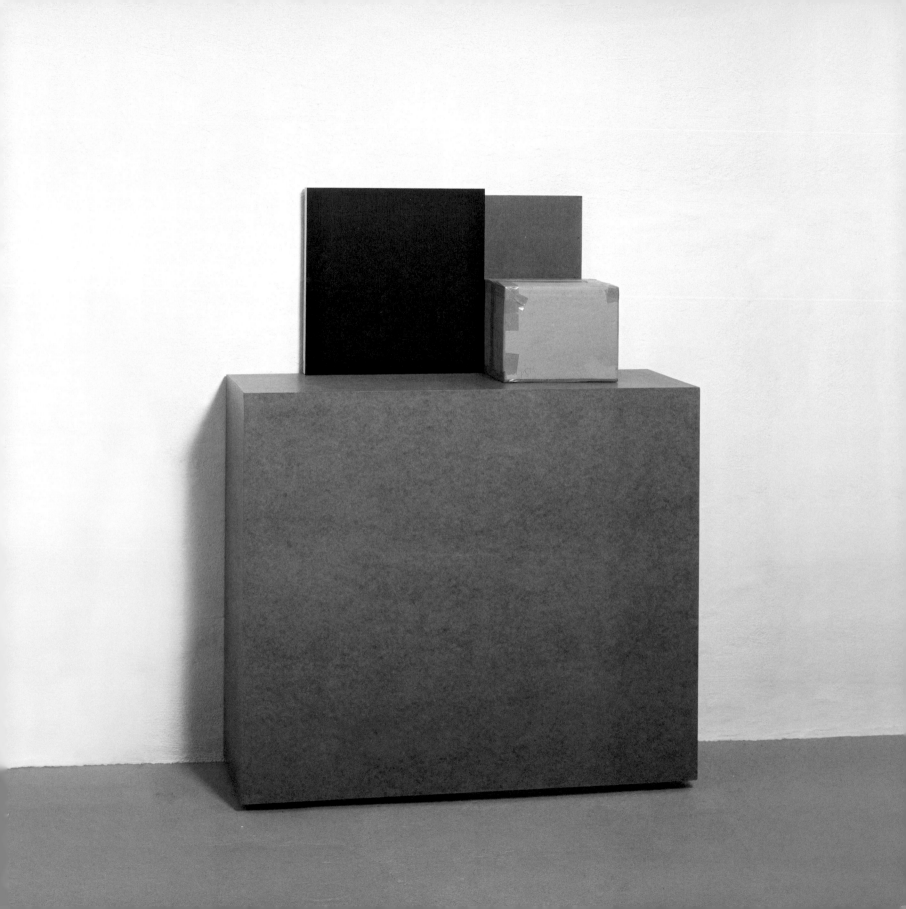

Blinky Palermo

'Untitled' 1969
Dyed fabric on undyed fabric
198.5 × 198.5 cm

Today, un-painted paintings are, if not common, then routinely accepted along with their more traditional counterparts. Within the once hallowed realm of painting we find works that involve neither paint nor brushes nor canvas in their production. In their place we are confronted with inks and Epsom printers, pictures delivered from an auto body paint shop rather than from an artist's studio. For better or worse, anyone can call almost anything a painting if it appears even remotely pictorial, on a pliable material stretched over a wood support, or is hung nearly flat to the wall. There are many other variations, of course, but the space of painting is occupied by all sorts of pictures that would not have been given the designation forty-five years ago. That the current generation of artists is able to engage in a dialogue with the history of painting, to fluently speak its language, but without recourse to its basic materials, is in part due to the work of Blinky Palermo.

When he was in art school in the early 1960s as a master pupil of Joseph Beuys, painting was looked down upon. It was not a form one would adopt in the pursuit of advanced art, and yet Palermo, as with others at the time, most notably Imi Knoebel, Sigmar Polke and Gerhard Richter, did just that. Palermo would go on to develop his *Stoffbilder*, or sewn fabric paintings, minimal compositions made from commercially available fabric which was cut, stitched together and mounted onto wooden stretcher bars. Produced between 1966 and 1972, these works are remarkable for their simultaneous radicality and classicism, of which *Untitled* 1969, with its wide format and high 'horizon line', is highly representative.

One grasps immediately that although there has been no application of paint, this work is not the result of any antagonism towards the medium, neither refutation nor negation. The exact opposite is true. These paintings are notable for their clarity and directness, their modesty and materiality, a revelling in a play between radiant hues and sober tones, lights and darks, luminosity and density. Palermo is one of the great colourists of his time, a fact that is appreciably heightened when one acknowledges that in this period, faced with so-called advanced painting, we might facetiously ask: who's afraid of white, black and grey?

When we consider the achievement of the *Stoffbilder* in relation to what led up to them and to what followed, we see an artist who is clearly aware of, and to some degree indebted to, the legacy of Kasimir Malevich, Piet Mondrian, Barnett Newman and Mark Rothko. Palermo wouldn't encounter the work of Ellsworth Kelly until after he had introduced his fabric pictures, but Kelly, particularly with his work of the early 1950s, is the historical figure with whom we most identify a strong correspondence. To place Palermo's *Stoffbilder* up against the work of younger artists who today appropriate and inhabit the signs and space of painting, is to grasp how important his work was and continues to be, something from another point of time entirely, yet which speaks so clearly to ours.

Born Liepzig, 1943, died 1977.
Lived and worked in New York and Düsseldorf.

BN

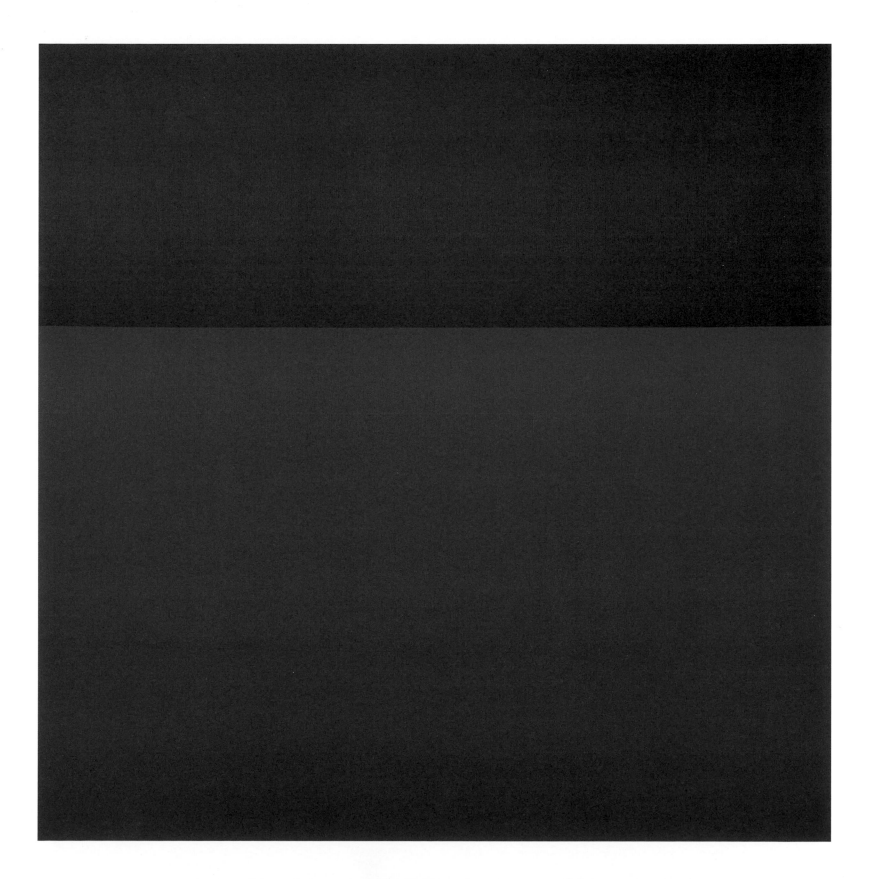

David Diao

‘3rd International/Tatlin’ 1985
Acrylic paint on canvas
3 panels, overall size:
269.24 × 132.08 cm

[1]
Michael Corris, 'Medals of Honor
and Flags of Convenience:
The Paintings of 'David Diao,' in
David Diao 1969–2005, exh. cat.
Beijing 2005.

The years 1984–5 represent a pivotal time for David Diao. Working as a painter in a 'formalist' vein since the late 1960s, he'd reached an impasse. Painting had become boring, and he had effectively given it up. Diao was largely self-taught (he'd studied philosophy at university). He has explained that whilst making abstract paintings constituted his education as an artist, it came to be a problem when he realised that merely putting down a straight line meant he was already fixed in an idiom of rationality, and likewise putting down a daub inevitably signified 'feeling'. The breakthrough came when he gave up on the idea of invention all together, and realised that he could, in his words, grab the 'existing residue' of visual imagery and use it as a starting point. Supported in this revelation by critiques of originality—whether Rosalind Krauss's important 1984 book *The Originality of the Avant-Garde and Other Modernist Myths*, Walter Benjamin's essay 'The Work of Art in the Age of Mechanical Reproduction', or Jean Baudrillard's writings on the simulacrum— Diao turned to photographs for both composition and subject matter in a new painting project that continues expansively to this day.

And the first image Diao reached for? The installation photograph of Kasimir Malevich's *0.10 The Last Futurist Exhibition* of 1915, one of the iconic images of modernist abstraction. In a group of around a dozen paintings Diao radically simplified the photograph and orientated our attention toward the spatial arrangement of Malevich's installation. Flattening out 'content' (which itself defines the photograph), repeating the same image across many paintings, and sometimes redoubling the reduction to suprematist/Communist colours, Diao used the reproduction to paradoxically open up a wide terrain and make painting 'porous' (his term) and able to take account of its elaborate historical effects. In *3rd International/Tatlin,* Diao stacks three canvases that have three different image sources: the bottom one references the *0.10* exhibition, and the top one is a near copy of Malevich's 1916 *Suprematism (Self-Portrait)*. The middle canvas is a copy of a 1964 painting by Blinky Palermo, *Composition with 8 Red Rectangles*, itself a working-through of Malevich's idiom. And the title's reference to Tatlin? Diao explains that it

follows a general logic of constructivist arrangement. There's a rising and slanting tower there, like Tatlin's famous unfinished monument, also existing now only in photographs.

Diao claims that painting this way simply creates a space in which he can address whatever interests him, and this includes logos and artists' monograms (especially ones from the early modern period), emblems of modernism (like Matisse's cut-outs), pop cultural images (notably Bruce Lee; Lee also being Chinese-American), and the typographic communications common to the art world (Diao did a show of paintings of his own CV and sales charts). Nonetheless, Suprematism generally and the *0.10* image recur in paintings to this day. What's the special relationship? Critic Michael Corris argues: 'For Diao, the proper response to modernism's internal contradictions is a full and frank public admission rather than a wholesale rejection.'[1] I suspect too that Diao's work accommodates our changing relationship to modernism, as well.

**Born Chengdu, Sichuan, China, 1943.
Lives and works in New York.**

AG

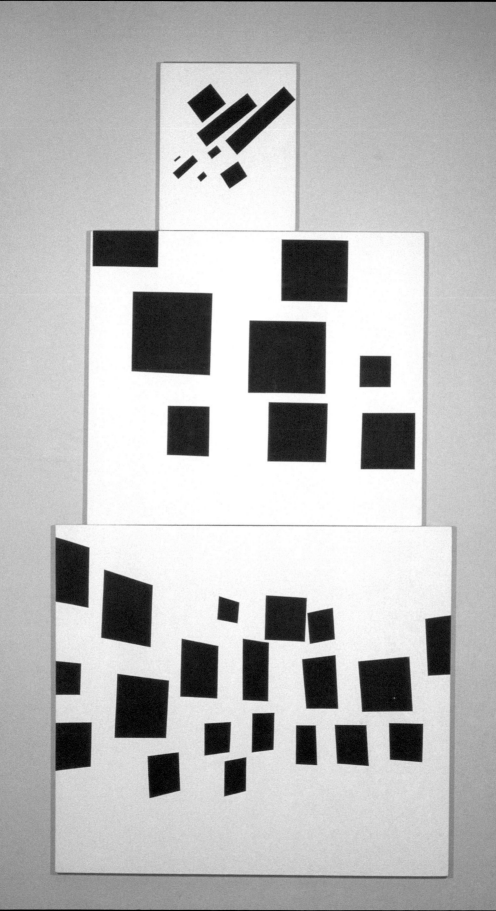

Martin Barré

'65-S-9' 1965
Spray paint on canvas
80 × 74 cm

[1]
Martin Barré, cited in Catherine
Millet, 'Interview with Martin Barré',
Art Press, no.12, June–August 1974.
Reprinted in Yve-Alain Bois et
al, *Martin Barré*, Cologne 2009,
p.260.

*This reminds me of what Cocteau said:
'The work must erase the work; people must
be able to say, I could have done that.'*
Martin Barré [1]

This work is characteristic of Martin Barré's sequence of works made between 1963 and 1966. During this period he produced around fifty canvases, consisting only of matt black spray paint applied rapidly to primed canvases of modest dimensions. The work may be said to pose the question: what are the minimum conventions which constitute a painting? The question had been posed in Clement Greenberg's essay 'After Abstract Expressionism' in 1962, and much painting in the 1960s would attempt to grapple with painting's push towards degree zero. Few, if any, pushed as far as Barré in this regard. He reduced his palette to black and white, and dispensed with the use of the brush or palette knife, in an attempt to reduce the painterly gesture to its minimal level of articulation.

Barré had attempted to achieve this in preceding works from the 1960s, which had consisted of squeezing the paint directly from modified paint tubes, but in the phase beginning in 1963, Barré used spray cans to eliminate more decisively the direct link to the artist's hand. In doing so, he attempted to circumvent the problem of the gesture as an index of the painter's personality or temperament, stripping it of the heroic connotations of either American or French abstraction in the 1950s. Instead, Barré foregrounds the indexical quality of the gesture as such. The mark, which juts in from the left-hand side of the canvas, bears the trace of its movement in space. It stresses the surface of the canvas, but without eliminating the built-in sense of pictorial depth which any mark on a surface invariably elicits.

As in much advanced abstract painting of the mid-1960s, the edge of the canvas takes on particular importance. The edge functions as drawing, in determining the limits of the pictorial field, but it simultaneously suggests the mark's movement beyond the frame. By truncating the painterly mark, the edge militates against the possibility of reading the gesture as calligraphic, and thus capable of direct signification. The associative connotations of the gesture are not completely denied, however. Spray paint inevitably calls to mind the graffiti artist's trace. The speed of the graffiti artist is a matter of necessity, however. For Barré, the speed of gesture is neither spontaneous nor necessitated by circumstance. Rather, his is an art of deliberation, acutely conscious of the tradition of the monochrome and its continued repercussions for painting throughout the 1960s.

**Born Nantes, 1924, died 1993.
Lived and worked in Paris.**

SM

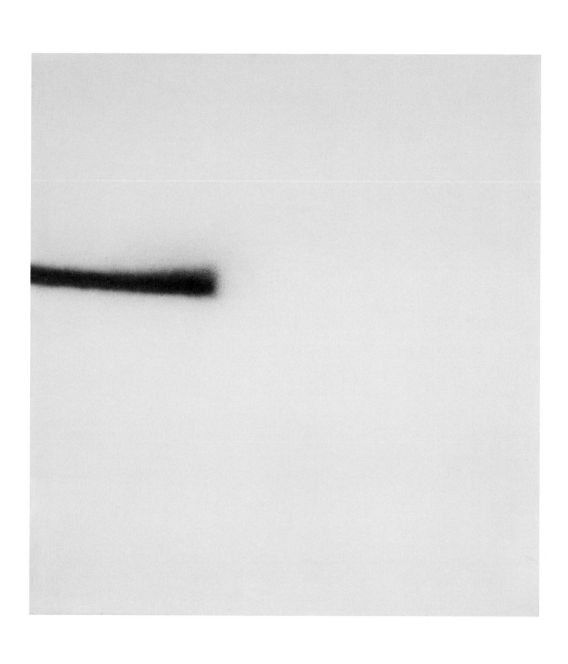

Michael Craig-Martin

'Mirror Painting' 1990–2011
Acrylic paint on aluminium panel
and mirror
233.68 × 127 cm

The original *Mirror Painting* was exhibited in 1991 at the Waddington Galleries in London. The piece, produced in household paint, is no longer extant, and has been remade for this exhibition in acrylic on aluminium panels. On its first showing, the work was exhibited with a series of paintings which reduced their pictorial means to a minimum, consisting of the non-hierarchical repetition of 'dashes' on the surface, in this instance, vertically orientated. Although *Mirror Painting* is more explicitly reductive than the depictions of everyday objects produced by Craig-Martin in the 1980s and 1990s, it nonetheless relates strongly to his long-standing interest in the nature of representation. Between 1988 and 1989, Craig-Martin had produced a series of pieces made from venetian blinds. These pieces play upon the notion of the picture as both a window onto the world, and as an object with its own stubborn materiality.

Painting's materiality had come to a head with the advent of minimalism. Despite the predominance of three-dimensional objects, Donald Judd famously remarked that the movement was closer to painting than to sculpture, and many minimalist practitioners were initially painters before making the transition into three dimensions. Further, the serial and systemic procedures of minimalism could be adopted to the practice of painting. The dashes which repeat up and down *Mirror Painting* exhibit these paratactic procedures. Placed upon the surface of a painting, however, these dashes inevitably perform a figurative or notative function, suggesting the minimal level of pictorial articulation. That the dashes were masked off with tape strengthens this association: Craig-Martin's wall drawings of common objects used tape as the figurative 'line'.

The use of the mirror, which bisects the work in two, is crucial. Craig-Martin had first used a mirror in a site-specific project while a student at Yale University in 1965, and had returned to the motif intermittently in the 1970s. Mirrors are central to Western pictorial art: Fillipo Brunelleschi had proposed that his depiction of the Palazzo Vecchio in linear perspective be viewed using a mirror. The mirror, then, is not simply a pictorial aid, it is a ready-made picture, existing as a real object and as a fictive space. In

Mirror Painting, the mirror performs this dual function; it is a real object fixed to the canvas, but it also functions to reflect the surface of the picture. The picture surface in turn is itself both real, in its assertion of materiality, and fictive, in that the non-hierarchical dashes intimate a basic level of notation. The work therefore plays upon this unstable relation between painting and the real, illusion and materiality.

Born Dublin, 1941.
Lives and works in London.

SM

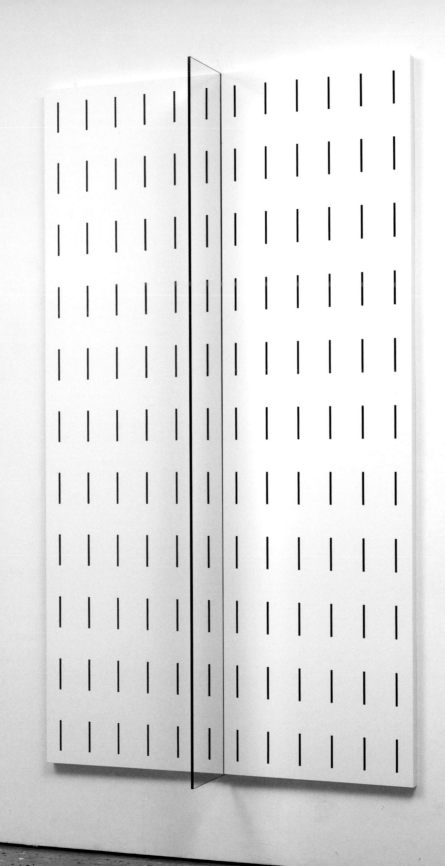

Niele Toroni

'The Vertical Imprint of a
Number 50 Brush Repeated at Regular
Intervals of 30 cm' 1988
Acrylic paint on canvas
200 × 200 × 3 cm

As part of B.M.P.T.—along with Daniel Buren, Olivier Mosset and Michel Parmentier—Niele Toroni first gained prominence with his particular painting gesture, *The Vertical Imprint of a Number 50 Brush Repeated at Regular Intervals of 30 cm*. Working in this way for more than forty years, Toroni has maintained a relationship to painting which is constant, while always adapting it to a given context. His work asserts that how a painting is made and how it is deployed determines how it is received. The image is unwavering, while the painted object responds to its ever-changing circumstances. This we can immediately grasp with the 1988 painting in this exhibition. Installed at an angle, meaning that its left and right edges straddle two walls that form a corner, the painting unequivocally announces its objectness—as if it was a speaker in the gallery—and, despite the seeming passivity of its overall image, insists on actively occupying the space of the exhibition. While it may be tempting to identify its position as referring literally to painting 'in a corner', this would be mistaken. This work calls to mind Kasimir Malevich's iconic *Black Suprematist Square* 1914–15, famously exhibited in 1915, hung high up on a wall across the corner of the room. While Toroni's painting is hung at a height relative to other pictures, its surface is not parallel to the wall, and is thus at odds with the placement of painting. And yet Toroni's gesture is the most elemental within that tradition: a mark made on canvas with paint and brush, nothing more but nothing less.

This work may strike us as having a direct relationship to its environment, as being site-specific in every exhibition, but it compels us to see that this holds true for any painting of Toroni's, and helps us to understand this sense of an artwork's life, how it inhabits space. As self-referential as Toroni's work appears, it is not a closed system, but engaged within a kind of loop that includes the architecture and the company in which it finds itself, other artworks and vernacular objects which are present, the viewer, museum guards and even a fly buzzing around the room. Toroni's paintings have been installed on top of gallery walls that have been similarly marked by the brush repeated at regular intervals. In these instances, the painted canvas hides, as it were, in plain sight. There is a continual element of touch in Toroni's work; although this is of paramount importance, there is little or no discernible emotion. The artist is present and absented from the final work. His brushmark is now readily identifiable as his 'signature', yet authorship and anonymity coexist, reminding us that his conceptual foundation is based on the undermining of painting's hierarchical status, and the work's built-in adaptability. In December 1967, Buren, Mosset and Toroni publicly painted their own work, and then that of one another (Parmentier had by then departed). In a world where a common response to art is the facile rejoinder, 'I can do that, too', B.M.P.T. were unfazed: 'Of course, go right ahead. We did.'

**Born Locarno-Muralto, Switzerland, 1937.
Lives and works in Paris.**

BN

Daniel Buren

'One of the Possibilities' 1973
Paint on dyed canvas
90 × 1600 cm

[1]
The show took place in an apartment at 16 Place Vendôme. It was organised by gallerist and critic Michel Claura and philosopher René Denizot, and included Buren, Toroni, Alan Charlton, Giorgio Griffa, Bern Lohaus, Brice Marden, Agnes Martin, Blinky Palermo, and Robert Ryman. See *Opus* 47 (November 1973); *Opus* 61/62 (January/February 1977); and *Daniel Buren: Mot à Mot*, Centre Georges Pompidou, Paris 2002.

[2]
The controversy around the Guggenheim show is well known. Buren's polemic against Szeemann, 'Exhibitions of an Exhibition' was reprinted in Jens Hoffmann, (ed.), *The Next Documenta Should be Curated by an Artist*, Frankfurt, 2004. The text with later commentary by Buren is available online at: www.e-flux.com/projects/next_doc/.

[3]
Daniel Buren Artist Catalogue file, Tate Archive.. Buren helped set it up for its second show in the apartment-gallery of the dealer-agent Ghislain Mollet-Viéville in Paris.

[4]
Ibid.

[5]
Daniel Buren, *Reboundings: An Essay*, Brussels 1977.

Daniel Buren is renowned for the radical, confrontational and site-specific works he makes in museums and other situations. In late 1966, Buren and three other painters (Olivier Mosset, Michel Parmentier and Niele Toroni) formed the short-lived B.M.P.T. group to propose painting as a 'game' rather than a creative practice. From that year forward, Buren worked with striped awning cloth and striped paper as his medium and style, and began to deploy it in various forms to intervene in public spaces and buildings. *One of the Possibilities* was made by Buren for the 1973 exhibition *Une Exposition de peinture réunissant certains peintres qui mettraient la peinture en question*.[1] One of many exhibitions at the time that occupied spaces temporarily and had the full participation of artists, Buren made what he calls his *peinture-sculpture* that measured 16 metres in length and spanned two rooms across a corridor that ran between them. This was an exciting experimentation with the kind of spaces painting could occupy and the freedom of using ready-made materials to do so.

It is relevant to mention that although this was an early show for Buren, he was by no means an innocent: it came after the censure of Buren's work by the Guggenheim Museum in New York in 1971 and after his very public confrontation with curator Harald Szeemann at *Documenta 5* the following year.[2] Buren's stridency in relation to institutional protocols and frameworks, however, needs to be seen against a surprising flexibility he builds into his works. *One of the Possibilities* makes this clear, even in its title, which Buren did not apply to it until it was shown for the second time, in 1984.[3] To make a site-specific work for Buren does not mean it cannot be moved. This returns us to the question of play: Buren builds in scenarios that make the work and its installation responsive to change, and thereby addresses the audience's understanding of the work each time, not as a representation of an intervention, but as a new piece. In the certificate that accompanies *One of the Possibilities*, Buren explains certain parameters, such as 'it may completely surround a room, [and] can extend through other rooms.' He writes: 'the placement of the work should be level with the floor or level with the ceiling', and lastly,

'it is possible to present the work partially unrolled ... I suggest the roll stops as soon as it meets the first obstacle.'[4] And what does the work do in these concessions to site? It tends to dominate a space, covering windows and architectural details. It compromises other works of art, especially ones that play by the rules. And because of these things, it continues, even to this day, to do what Buren set out to do in the 1960s: 'nothing less than abolishing the code that has until now made art what it is, in its production and in its institutions.'[5]

**Born Boulogne-Billancourt, France, 1938.
Lives and works in situ.**

AG

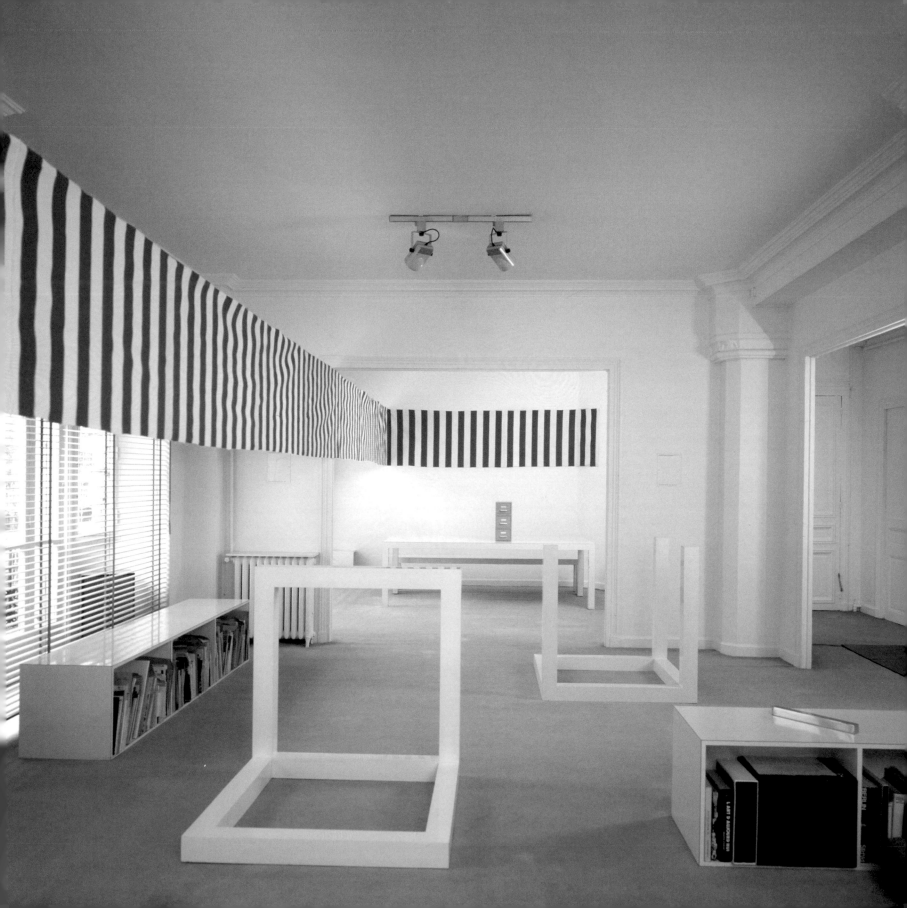

David Reed

'Untitled (no. 45)' 1974
Oil paint and acrylic paint on canvas
193 × 56.3 cm

This painting, part of David Reed's *Brushstrokes* series from 1974 – 5, takes as its basic form the brushstroke: not as an expressive gesture, nor even as a self-consciously ironic nod towards it, but as a material trace in itself. The mark is an index of the artist's hand and arm as it moves across the surface. Having prepared a wet white ground, Reed loaded a wide brush with black paint, briskly making a series of strokes into the surface from left to right. The speed of movement functions as a constraint, allowing the artist to avoid deliberating upon each mark; instead, Reed is compelled to condense thinking and doing into a single movement. Each stroke is constrained by the physical reach of the artist. Forced to stretch for the uppermost bands, and to crouch down to complete the lower half of the painting, these physical movements are evidenced by drips and irregularities as each stroke moves briskly but unsteadily across the surface. The material properties of the paint are also in evidence in the finished work: the wet-into-wet blending between the black strokes and the white ground creates irregularities of tone, as does the force of gravity upon the paint as it is speedily applied to the surface.

As the viewer looks at the painting, they are compelled to glance rapidly from left to right, re-imagining the process of the work's production. The painting requires a kind of viewing distinct from the 'all-at-once-ness' of modernist painting. Instead, one could describe the spectator as compelled to scan the picture; the glance presupposed is that of the city-dweller, as though watching a car or a train pass by. There is also a more indirect association with the movement of film. Reed's emphasis upon the painterly mark—as the index of a temporal, material gesture—aligns him with the rubric of post-minimalism, a series of process-based practices which emerged at the turn of the 1970s but which notably excluded painting. Reed's work corroborates a claim made in his recent writings that it is unhelpful to view painting as an outmoded form in contradistinction to the 'advanced' practices of Eva Hesse or Bruce Nauman. Instead, paintings such as *Untitled (no. 45)* figure within this shared nexus of practices.

**Born San Diego, California, 1946.
Lives and works in New York.**

SM

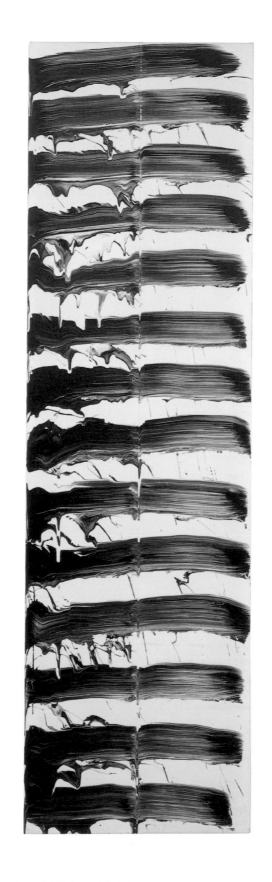

Jacob Kassay

'Untitled' 2009
Acrylic paint and silver on linen
122 × 91.5 cm

The common belief that representation lays a greater claim to mirroring everyday life is belied by artworks which reflect not only the world around them but their own circumstances. The parallel between reality and abstraction within picture-making is fully evident from impressionism onwards, as if congruent streams offered a new way of seeing a recognisable image: a riverbank, trees and the sky inverted on the tranquil surface of water below. The mirror as subject, whether painted, as by Roy Lichtenstein in the early 1970s, or imprinted, as in the 1960s portrait works of Michelangelo Pistoletto, can encompass representational, figurative and abstract images. In Pistoletto's polished stainless steel, one's gaze is returned as well as interrupted by the image; in Lichtenstein's canvas there is no materially reflective surface, and no visual loop within which we are caught in the act of looking. The silver monochromes of Jacob Kassay—on canvas but only painted in a preparatory stage—have it both ways: activated by the viewer and atmospheric conditions, and also entirely self-reflexive. While these works insist on painting as its own legitimate subject, and respond to ambient colour and light—they take on different tonalities at various points in the day—within the proximity of viewers and other artworks they 'perform,' animated by their presence.

These paintings of Kassay's are created by first priming the canvas with gesso and introducing surface effect—the frozen gesture of Lichtenstein's 'brushstrokes' is here called to mind—and then placing them face down in a bath of liquid silver. The process is similar to the electroplating of mirror to glass, and has an affinity with the fixing of images in photography (which Kassay studied). In the course of being plated, areas of canvas are subject to oxidation and residual burning. Kassay's preparation of the surface accounts for a measure of control and chance, and in the final stage his studio is a kind of darkroom where an image only then reveals itself at the last moment. As conceptual, alchemical, process-oriented paintings, they are very much of their time, moving in and around the act of painting with intimacy and distance, as in the work of artists such as Tauba Auerbach and Alex Hubbard. And yet they are also historically engaged, finding correspondence with

Yves Klein's 'Fire' paintings, Steven Parrino's metallic monochromes and Sigmar Polke's experiments with silver oxide and silver nitrate. The studio can be thought of as a kind of laboratory where tests are run and results are examined, and art proceeds, more often than not, when the 'failures' of the past lead purposefully to further research. This is perhaps what Kassay's silver paintings most accurately reflect today.

Born Buffalo, 1981.
Lives and works in New York.

BN

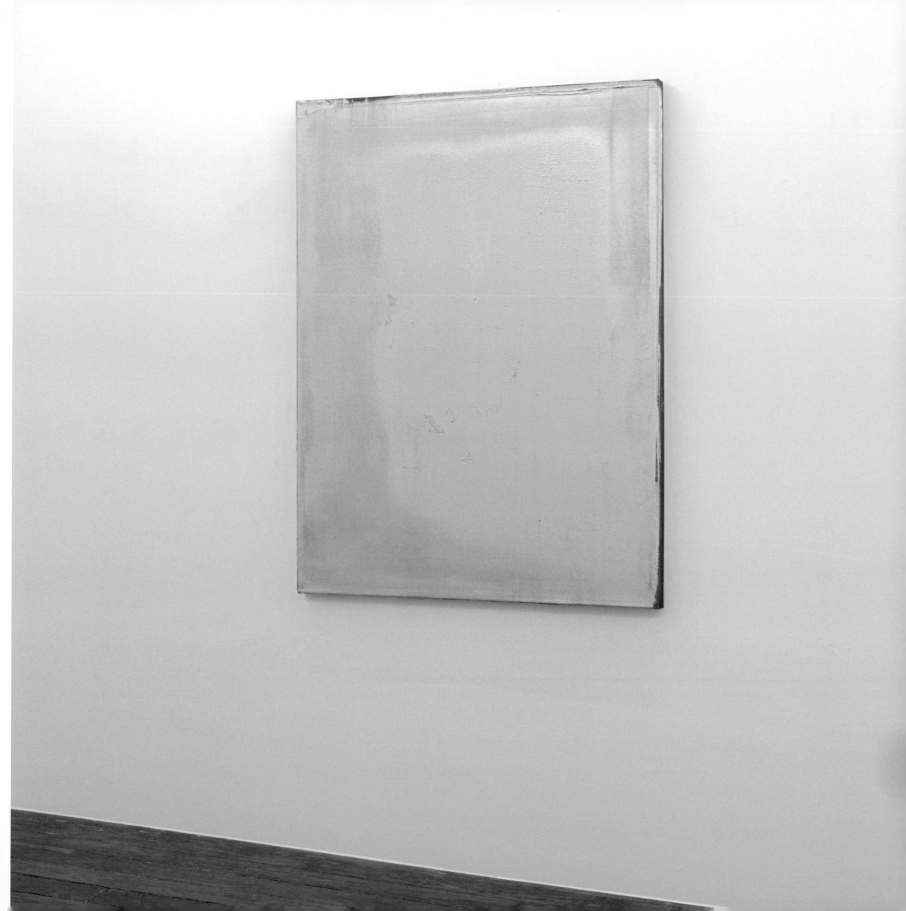

Sherrie Levine

'Melt Down (After Yves Klein)' 1991
Oil paint on mahogany
Each: 71.5 × 53 cm

It was inevitable that Sherrie Levine, one of the key figures in establishing the art that came to be known as appropriation in the early 1980s, would make a monochrome, the work that, above any other, contains the memory of all painting. It is within the monochrome that the central tenets of art after modernism reside; the notion that art is its own legitimate subject, and that the withholding of an image is tantamount to a political act. Of all the artists to whom she could direct our attention by way of her paintings, the fact that she chose Yves Klein is significant in both these respects. While other historic figures might seem to take precedence, and among Levine's earliest paintings are *After Kasimir Malevich* 1984 (a white on white square), and *After Ilya Chasnik* 1984 (a white cross on a black ground), it is Klein who looms as the master showman among practitioners of the monochrome. He is the artist who made paintings using models as human brushes, and by burning canvases with the assistance of a fireman, who emptied a gallery in 1958 and proclaimed it 'The Void: The Specialization of Sensitivity in the State of Prime Matter as Stabilized Pictorial Sensibility'; and sold, or transferred, 'zones of immaterial pictorial sensibility' to collectors against 20 grams of fine gold. In the most famous photo documenting this work, he is seen dropping the gold into the Seine. Art, after all, is about choice, and in choosing to quote from Klein, the mystic-alchemist of his time, Levine enacts an exceptional transformation by means of its ultimate conveyor, the monochrome: she turns art into art.

Chance also has its part to play, as a coup de théâtre, and can be a determining factor in the creation of art. Levine's *Melt Down (After Yves Klein)*, a horizontal line of eight panels, beginning with black and ending in white, is the product of just such an unexpected occurrence. The artist had expressed a desire over many years to make a monochrome, but never understood how it should be approached so as to correspond with and further engage her overall body of work. During her work on a print project that involved a computer averaging the colour in reproductions of images by Monet and Duchamp, an unexpected result was the distillation of the chromatic information as a series of monochromes. Levine was quick to co-opt them, and her comprehensive title for these works, *Melt Downs*, reflects the sense of pure reduction offered by the monochrome, leading her to Klein.

The term calls to mind the liquefaction that describes paint in its original state, as well as the processes of alchemy and dissolution. Gold is melted down and cast into bars or shaved paper thin, then affixed to canvas or tossed into the river. Images are melted down and turned into monochrome, monochromes are melted down and reborn. While the term has more recently been used in relation to nuclear and global financial disaster, the end of one thing is always the beginning of something else.

**Born Hazleton, Pennsylvania, 1947.
Lives and works in New York and Santa Fe,
New Mexico.**

BN

Richard Tuttle

'Paris Piece 1' 1990
Wood, acrylic paint, fabric and vinyl
137 × 97 × 16 cm

[1]
Artist's statement, in Bruce Kurtz,
'Documenta 5: A Critical Preview',
Arts Magazine, no.46, Summer
1972, p.39.

[2]
Tuttle, as quoted in Marcia Tucker,
Richard Tuttle, exh. cat.,
Whitney Museum of American Art,
New York 1974, p.5. Tuttle's
self-negation is the subject of
Richard Shiff, 'It Shows',
Richard Tuttle, in exh. cat.,
Museum of Modern Art,
San Francisco 2005, pp.253–76.

[3]
Tuttle, as quoted in Susan Harris
(ed.), *Richard Tuttle*, exh. cat.,
Institute of Contemporary Art,
Amsterdam 1990, p.166.

Richard Tuttle makes art that is precariously balanced. For fifty years he has explored form and its lack; language as imperfect communication; and materiality, both concrete and flimsy. He has often described his works as processes of reduction, but this only makes sense if you understand reduction as a starting point, like making a clearing in order to begin (early on Tuttle explained, 'The work is self-justification, by default, through rebellion, like the number – 1').[1] Looking over the many monographs and exhibition catalogues of Tuttle's work, you see an astonishingly productive and inventive artist, whose practice, despite a no-holds-barred attitude to experimentation, presents an unexpected coherence. It is all the more surprising, then, to read that Tuttle is interested in getting the artist out of the work. He has said he wants the work to seem 'ecstatic, as though the artist had never been there.' [2]

Paris Piece 1 comes from a group of works Tuttle made for a show at Galerie Yvon Lambert in Paris in March and April 1990. Some of the works were hung on the wall, others sat in the middle of the room. All were objects of a *bricoleur*—using materials like fabric, pieces of plastic, polystyrene and strings of electric lights. Tuttle is in the habit of making works on site as well as in the studio, and one wonders which of the materials might have come from Paris, and which ones came from his studio in the United States—even whether some works were made entirely on site. One imagines Tuttle tinkering, and this becomes a reminder that artworks that are as informal as these need a correspondingly high level of precision in their placement in space and final arrangement. One part of *Paris Piece 1* sits on the floor leaning lightly against the wall, another two elements are hung on the wall (whatever devices used to attach them are notably obscured). It signifies a provisional solution, but it is far from accidental. This piece no doubt sat in relation to all the other works in the room, since installations are a key part of Tuttle's practice.

How do you get an artist out of his or her work? One way would be to use a series as a kind of cover. Tuttle claims an interest in several exhibitions being 'a single conceptual unit'.[3] Thinking this way, a series creates space for invention because, in Tuttle's

methodology, elaboration and variation are not limited by any system. A series can continue sporadically, over years and across mediums and formats, moving, for example, from wall works to images in an artist's book. Or, a series can take a different or unprecedented direction, or allow the merging of two other modes of working. Against all this open terrain, the coherence Tuttle's work presents—the way it can match up the Baroque indulgence of *Paris Piece 1* with other more spare and minimal gestures— paradoxically leads back to him.

Born Rahway, New Jersey, 1941.
Lives and works in New York and Santa Fe,
New Mexico.

AG

Tomma Abts

'Thiale' 2004
Acrylic paint and oil paint on canvas
48 × 38 cm

[1]
In conversation with the author,
New York, 8 April 2008.

The paintings of Tomma Abts can often be seen as 'strange attractors', devices meant to draw the viewer towards them, or set up an intimate field based on mood, movement and energy that serves a heightened act of looking. She is careful in her picture-making to involve us in this encounter without simply seducing us, and the mood may be exuberant or reserved, the motion either graceful or awkward, and the energy nervous or freely flowing. This gives the paintings their unpredictable personality, and an animated life of their own. Like people, Abts gives them titles that remind us of names—they are complicated and not understood in an instant. If it takes time to become engaged with them it is precisely because the same is true for the painter who makes them; Tomma Abts is an artist for whom an image evolves on the canvas in the act of painting. It's not unusual for her to work on something and set it aside for a lengthy period before returning to it once again, or paint over what she has done—removing or re-composing elements, turning colour up or down and thus shifting the feel and intensities. She wants the viewer to be in close proximity with her work, almost in parallel to the distance she has with the canvas in her studio as the painting is being made. The small format of her pictures, always within a standardised 48 × 38 cm, has an almost one-to-one relationship with the head and the hand, and so bring into confluence human scale and the act of looking, one reason why she also usually shows the paintings low on the wall. As she once commented, 'The higher the ceiling, the lower the paintings are hung.' [1]

Thiale is a vibrant painting in spite of its sombre ground, enlivened by thin red lines that radiate from the centre, giving the image an inwards-outwards point of focus and departure. The lines create irregular triangulated forms at the edges of all four sides of the canvas, which come to life as a sort of fan with pinwheel motion. With two arcs of small ring forms that span the upper left and lower right corners of the painting, this sense of turning is dramatically reinforced, as is the depth of field. From the outside edges of the painting to its centre point there may only be a matter of inches, but the distance might as well be light years away. For all its performative associations— an abstract Ferris wheel illuminated on the fairgrounds at night?—to 're-trace' the lines which delineate its structure is to see just how perfectly and orderly the image has been composed, its radiant spokes and rings following a measured path around, or hovering above the picture plane. This is Abts's sleight-of-hand, her balancing act, always at work in subtle, considered ways, always meant to surprise us with an image that seems to have been there all along.

**Born Kiel, Germany, 1967.
Lives and works in London.**

BN

André Cadere

'Round Bar of Wood' 1973
'Barre de Bois Rond'
Painted wood
155 × 3 cm

[1]
See Magda Radu, 'André Cadere: Promenades and Refrains,' *Flash Art*, no.266, May-June 2009.

From the late 1960s until his early death in 1979, André Cadere made around 180 *barres* of wood. Aligned with many of the other anti-painting strategies of conceptual art and critical of conventional studio practices and relationships between artists and institutions, for Cadere, the key aspect of the *barre* was that it was portable. In practice this meant that in an exhibition the *barre* could be moved, it didn't have to be hung on the wall, but could be placed somewhere. Moreover, leaning casually, as if it had been left there without intention, a *barre* had the potential to be so unremarkable that a viewer might pass over it, or, if 'seen', force a recognition of the formalities of the white cube exhibition space. A *barre* could be used for street performances (announced or impromptu); or could be carried over the shoulder to art events. In this regard, whenever Cadere was holding a *barre* he was an artist, performing his practice in real time and real space. The work, then, is about both circulation and autonomy, and Cadere was notably subversive: he put *barres* in many shows to which he was not invited, and showed up late for ones he was. Invited to take part in *Documenta 5*, he was meant to walk with a *barre* from Paris to Kassel (apparently this pleased curator Harald Szeemann as a reference to that other Romanian artist, Constantin Brancusi, who notoriously travelled by foot from Bucharest to Paris). Cadere sent postcards from a faked performance and took the train instead, which prompted Szeemann to disinvite him—an obviously impossible task.

Cadere emphasised the *barre's* presentation as well as its use. *Barres* were logically conceived and their facture followed certain rules. They could be different widths and lengths, but the diameter of the coloured segment was always the same as its length. Cadere only used the primary colours plus black and white, and the pattern of colours followed a changing sequence, with the beginning and end sets exactly the same. There was always one intentional mistake, which, according to Cadere, made each *barre* unique. In this one, made of fifty-two units of green, white, yellow and red, it occurs five sets in, where the green and red units are reversed. As important as Cadere's adherence to system and chance in the making of his *barres* was his understanding of them as objects that signify in multiple ways. As paintings, their lack of hierarchy (no top, no bottom, no front or back) matters; as cultural objects they carry the air of a walking stick, but not a weapon—a French newspaper noted mordantly in the early 1970s that it was *not* a police-baton.

Recently, Cadere's specific cultural experience and national identity have been registered as a way of reading his notably nomadic strategies in a political, rather than exclusively art-world context. Some critics have emphasised his embrace of marginality in his formative years in Romania as well as the newly international movement of conceptual art he joined upon emigrating to France in 1967.[1] At the same time that Cadere's work was deeply situational (such that, for example, all *barres* were dated from their first outing) it was a daily, and highly personal practice, for which presence—the *barre* as well as his own—was crucial.

**Born Warsaw, Poland, 1934, died 1978.
Lived and worked in Paris.**

AG

Bob Law

'A Cross for Me and a Cross for You' 2003
Coach paint on canvas
25.5 × 35.5 cm

[1]
Stephen Melville, et al., *As Painting: Division and Displacement*, exh. cat., Wexner Centre for the Arts, Ohio State University, Columbus 2001.

[2]
Bob Law, 'Some notes on the essence of my work,' (1977) reprinted in *Bob Law: A Retrospective*, exh. cat., Richard Saltoun, London 2009, p.139.

[3]
Law fictionalised dates of paintings, for example with his *Impossible Painting*, dated 00.00.00. See *Bob Law*, p.30.

Bob Law's work, when it is painting, is only so by points of differentiation. Not self-expression, not object, not pure practice. It may be helpful to think of Law's work in relation to what critic and curator Stephen Melville has written about painting 'performing displacements'.[1] In a career that began at the very end of the 1950s, Law made these displacements in various ways: by limiting his palette of colours (often to just black or graphite so that when colour appears it stands out), and by reducing the amount of information a painting contains to the bare minimum. But then there were additions, which in Law's work amount to major events. One example is signing the work and putting its title and date on the front of paintings. Sometime between the 1950s and 1960s the fronts of paintings had been liberated from this convention; flouting such newly tacit rules, Law drew attention to how rules themselves are flexible and changeable. Similarly, Law shifted between abstract and representational formats, and did so with such minimal means that modes of representation were put up for examination (an example: adding sketchy smoke to a vertical rectangle in a drawing in his 'Castle' series makes it a chimney rather than a geometric element). Law's perennial use of black is reductive, but that inversion allowed him to explore differences in surface, sheen, material and colour. Law claimed he wanted 'to avoid the art of painting', but 'paradoxically at the same time the idea could not be presented in any other medium'.[2]

Kisses and Crosses, a series of small paintings, began self-consciously (possibly not truthfully) on the first day of the new millennium with a painting Law entitled *A Cross to Bare* [*sic*].[3] Painted with black coach paint on black canvas stretched over board (thus creating a hard surface) and then 'etched' with the end of the brush, in these works Law explored what he called 'the most primitive sign communication': the cross. In each horizontal rectangle there is first a 'frame' divided in half, and in the resulting vertical rectangles Law ran through a range of cross marks, from plus-signs to Xs to the combination of the two, which becomes an asterix. Titles—in Law's fashion, stamped onto the surface of the paintings— demonstrate the contradictory range of cultural meanings deployed by this most simple of marks: a kiss, a cross,

a double cross, and indicate how Law wanted to connect, in playful and paradoxical ways, visual language to its everyday uses.

Law was an English artist who, except for a short period, lived outside London and retreated from the art world after a brief but fascinating career in the 1960s and 1970s. In the best tradition Law was an autodidact, and his work is against abstraction. It is a compelling and sometimes difficult hybrid of conceptual tactics that mitigate authorship and expression, and expand and situate art beyond art, or at least beyond paintings and galleries and artworld networks. Something of his attitude can be gleaned from the titles of two series Law produced around 1970, *Mister Paranoia* and *Nothing to Be Afraid Of*: anti-authoritarian, invested in a newly configured 'self' but equally worried about a world ever more full of networks, bureaucracies and conspiracies.

**Born Brentford, Middlesex, 1934, died 2004.
Lived and worked in St Ives, London, Aix-en-Provence and Penzance.**

AG

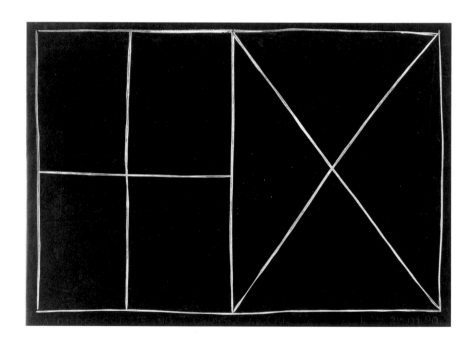

Francis Baudevin

'The Only Truth' 2010
Acrylic paint on wall
Dimensions variable

The interrelated interests of Francis Baudevin—geometric abstraction, graphic and product design, and the post-punk, no wave, and dance music of the late 1970s and 1980s—inform his paintings, wall paintings and photographic works. They come together as a kind of visual soundtrack, one that is amplified at different volumes according to the space or room for which they are intended. Beginning in the late 1980s, Baudevin's compositions closely appropriated the packaging of pharmaceuticals, pre-dating the better known 'spot' paintings of Damien Hirst by a number of years. While Hirst relied on a generic motif and its simple repetition in order to place a brush in his hand, Baudevin's approach evidences a thorough engagement with multiple sources, freely sampling in order to stimulate his painterly activity. Clearly, he registers no sense of any particular 'impossibility' to paint. The historical link between abstract paintings produced by Swiss artists working in the 1950s, 1960s and 1970s, and their parallel involvement with graphic design (often by economic necessity), can be thought of as a kind of co-dependence that Baudevin acknowledges in his own work. By removing all text, his source material is returned to a visual realm, and, whether produced in the studio or in situ, he reaffirms the purely artistic concerns of the painting practice, and those who came before him.

Baudevin's works based on record covers—and he is a collector who often buys an album for its cover design—have quoted directly from sleeves for bands such as the Buzzcocks, Delta 5, ESG, Liquid Liquid, the Raincoats (reproducing a figurative painting by Malevich) and New Order, the latter famously designed by Peter Saville. Baudevin's wall painting for Mead Gallery is based on a cover for Paul Haig's 12-inch, *The Only Truth*. It is faithful to the original composition, only reversed, enlarged, and with all text having been excised. The reversal, along with the removal of text, creates a far more dynamic situation. The shift in scale heightens the effect, to be sure, but even in modest reproduction it's clear to see that Baudevin's stripped down mirror image, which also reverses the colours in the original design, practically pops off the page just as it pops off the museum wall—in dramatic contrast to the record sleeve. The mostly awkward placement of the text on the sleeve somewhat hinders the composition, as well as the chromatic arrangement. While Baudevin is obviously enamoured of the designer's talents, he ultimately sees with a painter's eyes, and transforms the sleeve into an uninterrupted experience of form and colour, while the electro-dance track *The Only Truth* echoes in his head. Baudevin's wall painting is not an image printed on the sleeve which contains the record, but one painted in relation to the sound compressed in the record's grooves. In his cover version, the blue circle appears to be a record that has just emerged from the yellow sleeve.

**Born Bulle, Switzerland, 1964.
Lives and works in Lausanne.**

BN

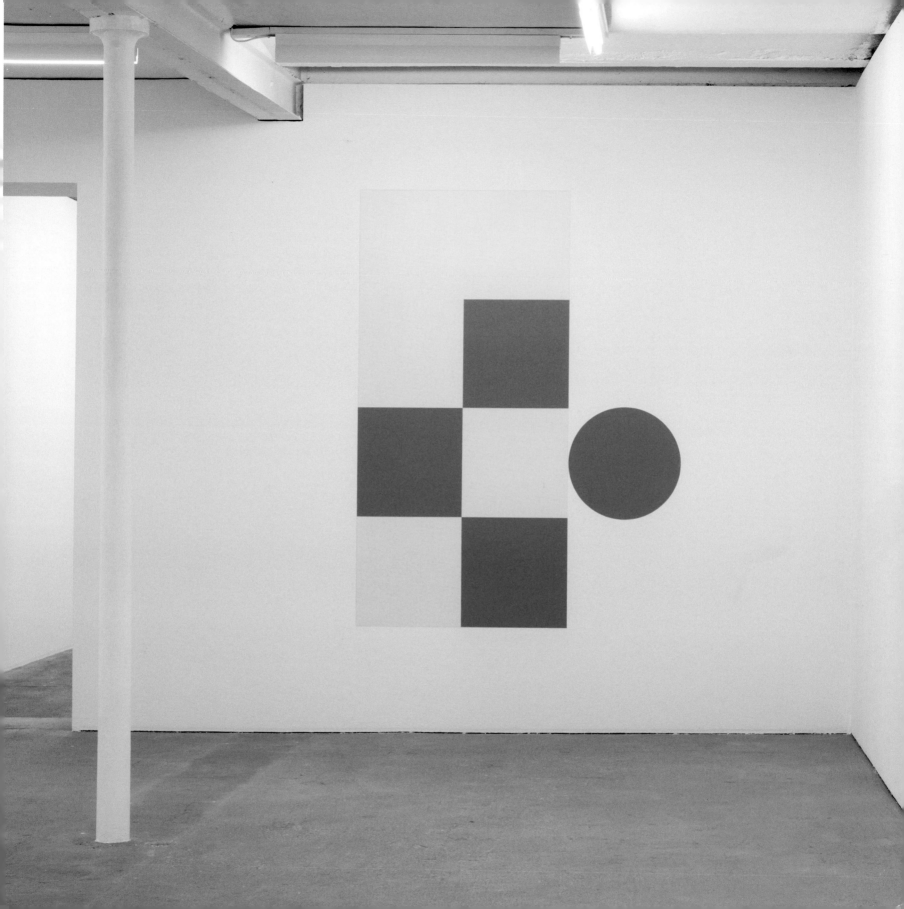

Frank Stella

'Hyena Stomp' 1962
Oil paint on canvas
198.2 × 198.1 cm

Frank Stella's work is situated at a particularly important juncture in the history of modernism: a point where the practice of painting threatens to splinter into competing factions. The date of the work is significant in this respect. Painted in 1962, the work is contemporaneous with the emergence of pop art and minimalism, and touches base with these movements, despite rearguard efforts by modernist critics to frame Stella within a narrow discourse of modernist abstraction. The instantaneous visual impact of the work, prized by modernists for affording an irreducible aesthetic experience, resonates with the attention-grabbing imagery of billboards and advertising, while the vivid, almost psychedelic colour scheme evokes the pleasures and instant gratification of consumer culture.

Formally, the hard-edged, literal quality of the painting, which emphasises the physicality of the surface, points towards the industrial surfaces of Donald Judd, who would prize Stella for the way in which his works project outwards into three-dimensional, real space. However, with *Hyena Stomp* Stella does not simply present an artwork as a mere physical object, nor does he provide us with the kind of pictorial space which easel painting previously afforded the viewer. Instead, the work toys with the gap between the two.

The apparently systematic arrangement of the concentric bands of colour may first appear to demonstrate what the modernist critic Michael Fried erroneously termed 'deductive structure', whereby the work's composition is determined by the shape of the framing edge. In fact, the placement of the right-hand triangular segment ruptures this concentric arrangement, creating an unstable vortex at the heart of the painting. Further, the diagonal edge of this segment is not flush with the top right-hand corner of the frame. In introducing these subtle pictorial ruptures, Stella demonstrates the more telling distinction which Fried would make in 1966 between 'literal' and 'depicted' shape, that is, between the shape of the picture itself and the shape of the forms depicted within it. Such subtle perceptual nuances may also be found in the plexiglass and aluminium structures produced by Judd during the 1960s. Stella's painting, then, is placed within a juncture of practices. His play with the ambiguity of the picture surface is not sufficient to keep it safely within the realm of 'pure' painting.

**Born Maldon, Massachusetts, 1936.
Lives and works in New York.**

SM

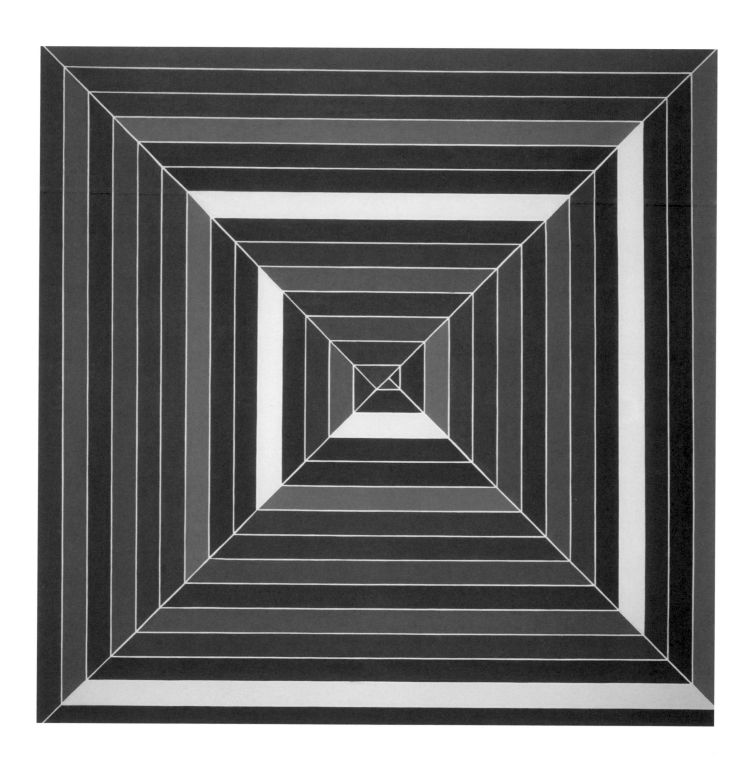

Karin Davie

'Symptomania 7' 2008
Oil paint on canvas
182.9 × 243.8 cm

[1]
See Barry Schwabsky, 'Karin Davie:
In the Thick of Painting', in
Karin Davie, exh. cat., Albright-Knox
Art Gallery, Buffalo 2003, pp.11–29.

Two 'contexts' underlie Karin Davie's often large-scale colourful and gestural paintings, and they are significant in defining her work in this medium. The first is a handful of private performances, photographed serially, given during her transition from being an art student to a painter in the early to mid-1990s, in an environment she saw as hostile to painting. These images implicate her body, movement, time, and—in their reminiscence of Bruce Nauman's late 1960s films and videos and the 'one-minute sculptures' Erwin Wurm has been making since the late 1980s— a kind of flaccid impossibility of that body making anything meaningful. The second context is the 'points of reference' gathered together in a recent exhibition catalogue of Davie's work, groups of images that explain the generation of particular paintings.[1] There are pop cultural references (like the Loony Tunes credit image), paintings by other artists (Yayoi Kusama, Gerhard Richter, Bridget Riley), other kinds of artworks (Trisha Brown's dances, for example) and, of course, Davie's performance photographs. These are provided as revelations of both content and context for Davie's otherwise abstract art. It is significant that the provision is intentional and unlike, for example, the 'discovery' in the 1990s of figures in Jackson Pollock's abstract paintings. Here is painting announcing itself as open to the world around it.

Symptomania 7 presents itself as a continuous gesture, writ large and to the limits of the size and physical capability of an ordinary body. The brushstrokes are fluid and fast, and you might imagine Davie made it all in one go. But a cursory examination suggests it wouldn't be possible to sustain the paint on a brush over such a long line, and nor would it provide Davie a way of changing the paint colour. She had to periodically stop to rest and reload, but where are the 'ends' of the strokes? And how to account for the glimpses of an acidic green in the background, which does not so much appear to be ground as another, buried, painting. It is tempting to suggest that some *magic*—'art' in another sense—is at work here, something close to *techne*, the Greek idea of craftsmanship which identified a doing-based knowledge. Indeed, since around 2003 Davie has stopped making drawings in advance of her paintings. The title of the painting—also the title of the series to which

it belongs—registers a place an artist might find herself in making abstract paintings nowadays: a displacement implied by 'symptom' (not the illness itself, but a material reflection of it) and an embrace of the 'mania' of painting, and with that all the received ideas of painters obsessed with their practice.

So this is the paradox of Davie's work: they appear, and appeal, as action paintings, and encourage us to move, or imagine movement, in relation to what we see. Her sources then do not direct or delimit her work. But neither are they covered up or denied as so much 'literature' in favour of painting's self-evident materiality. They are really alibis, which cannily distance Davie from unreconstructed Romanticism, but sit compatibly on the side as she gets on with painting.

Born Toronto, 1965.
Lives and works in New York.

AG

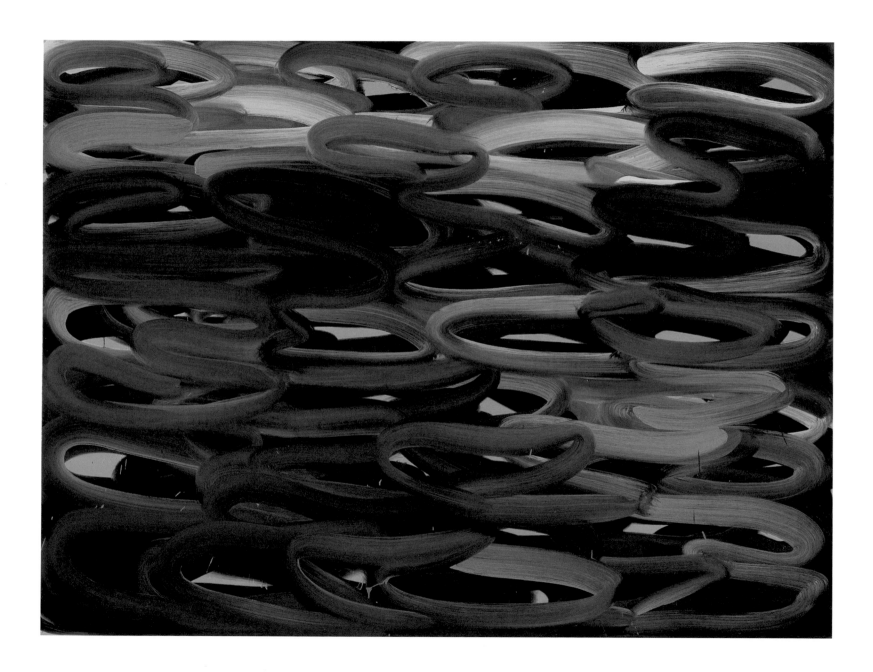

John M Armleder

'Brillian Xanthinus Arborescens' 2008
Mixed media on canvas
300 X 200 cm

The 'Pour Paintings' John M Armleder has made since the 1990s are perhaps his best known. Their origins however, are in poured works that he made in the early-to-mid 1980s, and they join everything he made previously, and subsequently, in what we might call the ever-unfolding retrospective of Armleder's readymade art. His history is to some degree a recycling of everything of interest that has come before him, of his own ideas and procedures, and of whatever happens next. His is one of the most enviable positions in art today, for any work that he makes will have its source, or multiple points of departure, and be seen as his own creation. No matter what our associations are, and they can be many and even contradictory, anything he does is seen as a work by John M Armleder. Every artist that we might think he quotes from is, in a sense, his studio assistant, and yet Armleder would rightly insist that he is also theirs, at least after the fact. With the 'pour paintings,' as we see clearly in *Brillian Xanthinus Arborescens* at Mead Gallery or *Cimicifuga Cordifolia*, (illustrated opposite), his most essential assistant is nothing less than gravity.

Armleder came out of Fluxus— with its close ties to chance operation—and in performance, which most often exists in real time, even when scripted and rehearsed, there are no guarantees for the final act. Confronted by his 'pour paintings,' we witness the result of a performance—the artist perched at the top of a ladder, usually impeccably dressed, tilting various cans of liquid toward the surface of a canvas, and letting nature do the rest. He may later add a small snowfall of glitter, or embed starfish in the unctuous pools of varnish, but the work appears almost instantly in the process: the artist performs and the material behaves. And there is no anxiety for success, since Armleder finds merit in every work of art, even those to be avoided. There have been many 'pour paintings', and certainly there will be more, but there has never been a bad one, nor will there ever be. Armleder is very likely among those few practitioners in the history of art who has never thrown anything away. And why should he? This would amount to the repudiation of what might be one of his guiding principles: whatever one doesn't do, doesn't matter. Whatever one makes, exists. 'Pour paintings' have existed before—from Morris Louis, Jackson Pollock and Larry Poons to Lynda Benglis, Sigmar Polke and Pat Steir— and will continue to be made. Although these paintings of Armleder's will inevitably remind us, and the artist himself, of works made by others, a John M Armleder 'pour painting', in the end, resembles nothing so much as his own, original work. It is because, for all the varnish, bronze lacquer, aluminum paint, pigment, powdered glass and glitter, what these works are truly infused with is a particular attitude, a unique sensibility that drives everything that John M Armleder does.

Born Geneva, 1948.
Lives and works in Geneva.

BN

Installation view:
Cimicifuga Cordifolia 2008, Mixed media on canvas
300×200 cm in *Scrambled and Poached*, Simon Lee Gallery, London
25 June–29 August, 2008
© The artist. Courtesy of Galerie Andrea Caratsch, Zürich
Work not in exhibition

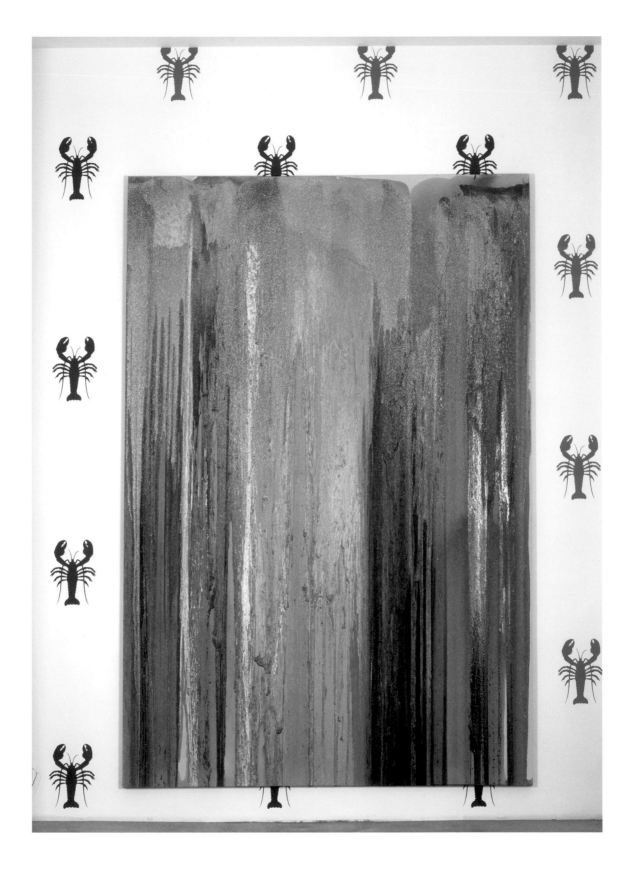

Peter Davies

'Small Touching Squares Painting' 1998
Acrylic paint and pencil on canvas
254.2 × 457.2 cm

The immediate point of reference in Peter Davies's *Small Touching Squares Painting* is the 'Process Painting' produced by a group of British painters in the mid-1990s, including, but not limited to, Ian Davenport, Alexis Harding and Jason Martin. 'Process' here referred to the procedure whereby the conventional application of the brush to the canvas is circumvented through procedures such as dripping, pouring or, in the case of Harding, drilling holes in a trough in order to apply the paint to the surface. Davies's work is also guided by a specific procedure, but instead of a quick 'one-shot' process, the process involved is painstaking and obsessive. There is inevitably a different aesthetic outcome.

The large triptych of canvases consists of a surface of tiny adjoining squares, which are sequenced diagonally in a variety of appealing hues. The work is characterised most notably by the ripple effect created by Davies's procedure. It is neither the product of intuitive decision making, nor is it slick and pre-meditated. Instead, the process is slow and arduous. Instead of 'squaring up' the grid, Davies works across the canvas square by square, a process which involves the grid undergoing the inevitable distortions of human error, given the discrepancy between the large scale of the canvas and the small scale of the squares. Since each square is required to touch its neighbour, the grid is slowly pulled out of shape as each error produces a cumulative effect across the surface of the painting. The wonky ripple effect is perhaps better described as a weave rather than as a grid: it is fluid and responsive to human error, whereas the idea of a grid connotes the hard-headed or utopian ideologies of modernism. It is worth noting here the historical gap between Davies and the modernist legacy.

Davies's work demonstrates the mutability of cultural tradition: the modernism of the 1960s is not so much an organic tradition to which he belongs, but rather a reference point against which he is free to make his own interventions. Davies responds to his predecessors in a way that no longer corresponds to their initial conditions of production and reception. Davies's choice of painting as a medium is pragmatic, and his approach to abstraction is in keeping with the wry, irreverent nostalgia of the 1990s, particularly that decade's pop-cultural retrospection, exemplified by its 'Top 100' lists (itself the subject of a series of paintings by Davies). This irreverent attitude is offset, however, by the laboriousness of the procedure itself, and by the subtle violence which is hinted at by the work's pictorial 'glitch'.

Born Edinburgh, 1970.
Lives and works in London.

SM

Katharina Grosse

'Untitled', 2011
Acrylic paint on wall and window
Dimensions variable

Immersing oneself in a painting, not merely in the visual and cerebral sense, but with the sensation that it has been physically entered and one walks upon a painted landscape, raising small clouds of pigment with every step, might best describe the effect of Katharina Grosse's large-scale installations. To say that she is a space-invader, overtaking the architecture, scorching and defacing every surface—the walls, floors, columns, windows, doors and ceilings of museums—is merely to state the obvious, to be overwhelmed by spectacle. What is far more subtle is how attuned she is to composition, to form, light, colour and tonalities, to the visual dynamics of weight and buoyancy, to the movement of her brush and how paint is applied to a surface—in short, to everything that is central to picture-making as we know it through its history. While she also creates discrete works on canvas, what sets her apart from almost every other painter today is the ambition and intent with which she proceeds, nothing less than to create paintings which animate and inhabit—some might say haunt and destroy—the spaces in which they are exhibited.

Painting, for Katharina Grosse, is an event. To see her dressed in protective gear, including a ventilator through which she breathes as she paints spray paints a given space—somewhere between action painting and science-fiction—is to imagine painting as an airborne toxic event.

Traditional landscape painters find a vantage point for their easel, framing the view they plan to paint at their very feet, as it were. Grosse, with her interior or mental landscapes, offers multiple points of view for museum visitors, locations from which they are able to survey the painting that spreads out in numerous directions. The immersive experience is not merely to be represented, but to be witnessed, and the viewers play their parts. We can think of them as the figures in her very physical ground, as she often creates large earthen mounds in which to set sculptural objects, painted panels, boulders and stones. In her expansive painted environments, as with *One Floor Up More Highly*, the piece she created on site at MASS MoCA in 2010, (illustrated opposite), painting, landscape and earthwork come together as a total work of art. Grosse will sometimes 'salvage' painted panels from installations and present them as individual paintings in their own right.

a way to discover and reanimate pockets of energy. These works have some relation to the improvisation that Grosse enacts when given a more compressed space in which to compose a wall painting. In these instances it is interesting to compare her approach to that of someone who came before, and worked in-situ: Blinky Palermo, for example. While his wall paintings follow architecture in a more restrained, classical way, and Palermo's and Grosse's positions might be seen in terms of order and disorder balanced against one another, Grosse's project constitutes a kind of classicism for our time. She well understands that today, as before, we encounter the sublime as equally beautiful and terrifying, a source of both wonder and dread.

**Born Freiburg/Breisgau, Germany, 1961.
Lives and works in Berlin.**

BN

One Floor Up More Highly, mixed media installation at MASS MoCA 2010–2011
© The artist and VG Bild-Kunst, Bonn, 2011.
Courtesy of Christopher Grimes Gallery, Santa Monica and Galerie nächst St. Stephan, Rosemarie Schwarzwälder, Wien.
Work not in exhibition

Mary Heilmann

'Pink Sliding Square' 1978
Acrylic paint and latex on canvas
60.33 × 60.33 cm

For more than forty years, Mary Heilmann has painted in and around painting, every image leading to every other. One could say that for Heilmann, as for those abstract painters of successive generations since the 1960s, marked by the rise of post-studio art and an abandonment of traditional ways of working, painting goes on despite periodic intermissions. An image is not only generative, but when we stand before a canvas we really only see a part of the picture. The rest is somewhere else, or yet to be painted. A filmic or theatrical metaphor is appropriate for Heilmann, for whom painting is a matter of a scene, or a sequence of scenes drawing us in, setting things in motion. *Pink Sliding Square* is one of two pink and black paintings that Heilmann made in 1978 that animate this idea, as well as set the stage for a number of paintings that follow. Here, the 'sliding square' is a large pink form that sits in front of, and to the left of a smaller square on a dark field. Despite the frontality, flatness and intentional dumbness of the composition, illusionistic space is very clearly suggested. The eye can't help but connect the two squares, rendering them in near-diagrammatic, perspectival relation to one other: two pink screens projected in a darkened room. The other work from that year, *The End of the All Night Movie*, is a small pink rectangle held in a field of black by a greyish vertical line or splice.

In the following year, Heilmann began *Tomorrow's Parties* 1979/1994, a diptych with, to the left, a black space vertically bisected by a thin white line (imagine a light leak in a dark curtain), and a black square on a pink ground on the right. With *Tehachapi #1* 1979, she offers a reversal of sorts: a black square on a pink ground up against a black space bisected by a thin pink line. Also dating from the same year is *Save the Last Dance For Me*, with two pink rectangles and a pink square on a black ground; the pink forms that abut the side edges of the canvas appear to have been abruptly cut. If we were to install all these paintings side-by-side, the effect might be likened to viewing sequential frames in an abstract film, rhythmically ordered, or disordered, by jump-cuts. We realise, because of some of their titles, and all of the visual syncopation, that there is a soundtrack to Heilmann's painted movies and screens, to her activity in the studio. *Tomorrow's Parties* calls forth the voice of Nico and the Velvet Underground's *All Tomorrow's Parties*, while *Save the Last Dance For Me* echoes the hit song by The Drifters from 1960. The 'sliding squares' that appear in the painting in this exhibition can be thought to have promiscuously shifted from other paintings, slid from one canvas to the next by an artist for whom there has always been another party and another dance, another night and another movie. For Mary Heilmann, the story of painting is that it goes on.

**Born San Francisco, 1940.
Lives and works in New York.**

BN

Keith Coventry

'England 1938 (1994–2011)' 2011
Household gloss paint on wood
274.3 × 76.2 cm per panel

England 1938 (1994–2011) utilises a format that can be traced back to Ellsworth Kelly's *Colors for a Large Wall* 1951, which consisted of sixty-four panels arranged in an arbitrary grid, obviating both traditional drawing and composition. The work is exemplary in demonstrating the impersonality characteristic of the most radical statements of modernist abstraction. Keith Coventry's work consists of 240 abutting panels, but his use of materials allows him to approach the legacy of modernist abstraction from a different historical trajectory.

The work has been produced using a set of tins of lead paint, utilising what the artist has termed a 'sign-painters aesthetic', whereby the paint is applied evenly and the edges of each colour abut against one another (Coventry worked as painter and decorator as a young artist). These tins, which all date from 1938, come from a series of British Standard Colours—colours classifed by the British Colour Council, which was set up in 1931 and published its dictionary of standardised colours for the building trade in 1934. Two different trajectories are thereby set up by the work: one is the history of modernism intimated by the composition, the other the social history embedded in the paint itself.

The use of these discarded tins of paint points to Coventry's recurring interest in the social underside of modernity. If modernism defined the cultural and artistic response to the modern, modernity signified the social and political condition which under-girded such a response. Central to modernity was the belief in progress made possible by industrial transformation, but Coventry's work and his use of lead paint tracks a hidden history of modernism, particularly its decaying architectural spaces and social deprivation. The pastel colours which predominate in Coventry's work suggest domesticity. Whereas the decorative signified modernism's aesthetic triumphs, the threat of mere decoration was ever-present. This anxiety stretches back to the emergence of abstract art in the early twentieth century, but found a particularly dramatic example in the work of Jackson Pollock. Clement Greenberg repeatedly used the motif of 'wallpaper' in defending Pollock's work against the charge of mere decoration. 'Decoration' therefore signified the domestic,

and this opens up the issue of the social repercussions of modernity. The colours which constitute *England 1938 (1994–2011)* were intended for use in homes, schools or other public institutions. Lead's toxicity, however, has left a silent but enduring legacy in many residential and public buildings. The pleasant decorative colours contain this sinister undertone, which is both intrinsic to the materials, but also suggestive of the wider issues of modernity's legacy of social decay.

**Born Burnley, Lancashire, 1958.
Lives and works in London.**

SM

Gene Davis
'Popsicle' 1969
Acrylic paint on canvas
165.1 × 165.1 cm

Gene Davis is not usually placed within the rubric of colour-field painting, despite being a contemporary of Morris Louis and a colleague of Kenneth Noland in Washington DC, where all three lived and worked. Davis's more playful and expansive attitude towards painting did not sit easily within this practice. The event entitled the *Gene Davis Giveaway* is a fine example of the artist's predilection for Fluxus. It took place on 22 May 1969 at the Mayflower Grand Hotel Ballroom in Washington DC. The idea for the event was devised by the art critic Douglas Davis in conjunction with the sculptor Ed McGowin, and later credited to Gene Davis. Their conception was to stage an exuberant event marking the end of the era of colour field painting, which was both celebratory and irreverent. The movement had been prematurely heralded by Clement Greenberg as the future of advanced art at the turn of the 1960s, but was by 1969 simply 'good taste', surpassed by other, more overtly radical practices.

There is nothing in this process unique to colour field painting. All avant-garde movements have a built-in obsolescence, and Gene Davis's statement for the evening explicitly acknowledged this. However, colour field painting was native to the artist's hometown of Washington DC, so he agreed to produce a work entitled *Popsicle*, a characteristic stripe painting which was slightly smaller than his preferred scale. Fifty editions of this work would be made by students at the Corcoran Gallery of Art, supervised by the artist himself. For the event at the Mayflower Hotel, 500 art world participants were invited. The fifty editions of *Popsicle* were raffled, the tickets drawn from a silver bowl, while the Dupont Circle Consortium played chamber music.

Although the works were raffled off as valuable commodities bearing the mark of 'Gene Davis', each canvas also bore the silkscreened signatures of Douglas Davis and Ed McGowin, along with names of the assistants on the back. The works were therefore a collective undertaking, albeit one where the commodity value was underpinned by the singular reputation of Gene Davis himself. The event therefore performatively enacted the co-option of colour field painting by circuits of commodity production. But by giving the work away

for free, Davis and his co-participants could be said to have made an intervention, momentarily disrupting the usual flow of commodities (these soon reasserted themselves; the pictures were shortly changing hands at an estimated $3,000 apiece). The event itself was not without its own complications: a box of documentation related to the evening was encased in a plastic box and 'silently' exhibited at Henri Gallery on 15 November 1969. The Henri Gallery exhibit was perhaps an attempt to crystallise the myth around the event itself, an ambition perhaps closer to the heart of Douglas Davis rather than Gene Davis. Further, disputes over how credit for the event should be apportioned was an issue in subsequent years, opening up wider issues regarding authorship, authenticity, and art's complicity with the market, and demonstrating that painting is no more or less complicit in its machinations than any other kind of practice.

**Born Washington DC, 1920, died 1985.
Lived and worked in Washington DC.**

SM

Peter Young

'#16-1968 (Dot Painting)' 1968
Acrylic paint on canvas
168 × 198.5 × 4.7 cm

[1]
Klauss Kertess, 'Tribe of
One' in *Peter Young: Paintings
1963–1980*, exh. cat., and P.S.1
Contemporary Art Center,
New York 2007.

[2]
Young explains that this
painting was made for a show
at Rolf Ricke's gallery in Kassel
(which fruitfully coincided with
Documenta 4), but since it was a
basement space with low ceilings
they had to be no more than
5 ½ feet tall. Email to the author,
30 June 2011.

[3]
Email to the author, 30 June 2011.

[4]
Young quoted by Ben La Rocco,
'Tracks: Peter Young: An Unlikely
Artist,' *The Brooklyn Rail*,
September 2007.

From the mid-1960s through to the mid-1970s, Peter Young made an astonishingly beautiful body of work that responded experimentally—within a relatively small range of visual rhetoric and procedure—to the gauntlet laid down by minimalism at the feet of American abstract painting. But that is less than half the story. Young's explorations drew from a much wider range of sources than those usually understood to be the frame of reference for abstract painters in that decade; the 'formalist' or 'pure' concerns with painting's 'medium' so forcefully argued by Clement Greenberg and converted to orthodoxy by painters in New York and elsewhere. The minimalists were no less ideological in asserting a limited arena for art: Donald Judd's 'specific object' was to be situated in the real world, but still all 'content' for art was abrogated. Instead, Young sought inspiration from living tribes, mind-altering drugs, and encounters provoked through his extensive travels conspicuously outside New York and beyond the circuits of the international art-world. One critic wrote recently, in a play on the famous quote by Frank Stella, 'Young preferred to practice a kind of what you see is what you don't see.' [1]

From the start, dots became something of a signature, although Young put them to very different uses. In some paintings they are clearly speaking in the vocabulary of tribal painting; in others they participate in the all-over strategies of abstract painting rooted in expressionism or geometry, and, of course, their links to decoration. *#16 – 1968 (Dot Painting)* is a relatively small work belonging to a series of larger-scale dot paintings Young began around 1967.[2] These were all abstract even though they followed a handful of paintings that looked like stars in the night sky. In this group, dots are arranged to seem equally pre-ordered and generative: shapes or trails are established with groups of dots in one colour, but very seldom does this cohere into an overall 'picture'. Young explains that his 'proposition' for arranging the dots in *#16-1968 (Dot Painting)* was to try to make each one equidistant from its neighbours. 'Isn't this a logical impossibility?' he asks. 'Though I knew it was impossible, I tried to figure out what it would more or less look like anyway.'[3] The perceptual 'buzz' in this painting is high:

the eye tries to form circles, which merge into other circles, and so on, before any real figure can be resolved. The dots are in fact irregular, even blotchy. There is colour, too, hidden underneath the white background (pink, green, yellow, blue), but it is experienced hovering unfixedly as an afterimage.

One of Young's dot paintings graced the cover of *Artforum* in 1971, and the next year he was included in the infamous *Documenta 5* curated by Harald Szeemann. But Young had left New York by then and was on his way to living more remotely in Arizona, where he is still painting, among other things. 'The question is not why I left New York but why I ever went there in the first place.' [4]

Born Pittsburgh, Pennsylvania, 1940.
Lives and works in Bisbee, Arizona.

AG

Ingrid Calame

'Step on a Crack,
Break Your Mother's Back' 2009
Oil paint on aluminium
101.6 × 61 cm

[1]
Telephone conversation with the
author, 1 June 2011.

Ingrid Calame belongs to a generation of artists for whom the 'expanded field' of painting was given, rather than conflicted, terrain. *Step on a Crack, Break Your Mother's Back*—like most of her paintings—relates to a specific place, in this case the car park outside the Albright-Knox Art Gallery in Buffalo, New York, where she was a community-based artist-in-residence in 2009. The pink, green, orange, blue and yellow 'tracks' we see across the painting's mauve background are traced full size from the patterns on the ground where the asphalt had cracked and been repaired with tar, and where, according to Calame, there was thus already a 'picture' that was interesting to look at in itself. With the help of assistants, Calame traces such marks on site onto enormous sheets of Mylar. Back in her Los Angeles studio, these tracings become source material for future paintings that are, in effect, copies of these originals, twice mediated. Calame explains that whilst the forms are quite clearly filled in, in a more or less mechanised and inexpressive manner, the colours come from sensations and memories and are chosen intuitively.[1]

About half of the critical essayists on Calame's work choose to see a 'reality quotient', and focus on the paintings as trace or index. They argue that her marks *are* the original marks of the place where they're from and fail to see her work as a process of translation and a site for exploring more complicated questions of representation. There are in fact different registers on which the real operates and convinces. We have the authority of site: a painting delivers us information about a specific place, and in theory we could find it and the two would match up. There's also the authority of the artist, who, in contradictory terms, demonstrates herself and studio practice as the site of mediation, choice, invention, imagination and feeling. There is also another authority at work in Calame's paintings, and this is the series of places she has chosen, or been invited, to work, such as the Indianapolis Speedway, the New York Stock Exchange and a working steel mill. These are major sites of power, institutional and difficult, with a whiff of late capital about them. Calame's entry into them seems extraordinary and significant.

By contrast, what is notable about this painting is its intimate scale (Calame explains it's the size of a typical poster), its 'feminine' colour schema, and the manner in which Calame 'merely' does her filling in of pre-existing marks. The surface is hard (the backing is a sheet of metal) and her brushstrokes are small, evidencing that even filling in requires decisions and a certain technique. Indeed, within the areas representing the marks, the brushstrokes go in different directions, as if there's a second order of information being registered—private to Calame's memory of the site or later thinking. Previously, Calame painted with enamel, but her recent changeover to oil paint foregrounds process over image. And lastly there is the site of production—her studio—with an ever increasing archive of templates which she can work indefinitely, making this much more than just a copy, but a remix.

Born New York, 1965.
Lives and works in Los Angeles.

AG

Peter Halley

'Two Cells with Conduit
and Underground Chamber' 1983
Acrylic paint, Day-Glo acrylic paint,
and Roll-a-Tex on canvas
177.8 × 203.2 cm

Peter Halley's work stands for something quintessential about art—especially the aspirations of painting—in New York in the 1980s. His work aimed to be oppositional and glamorous, handmade and artificial, theoretical and popular, grounded in the serious gestures made by the art of the twentieth century, but against the traditions of liberal humanism which modernism had come to embody.

Two Cells with Conduit and Underground Chamber is an early painting, made several years before Halley began to have regular shows, but it manifests the visual vocabulary and material production with which he still works: geometric shapes, lines and blocks of background colours that refer, as the title indicates, not to models for better living, nor sacred geometry, nor 'felt' forms, but to the cold mechanics of prison cells and silicon hardware design. Halley's techniques include using Roll-a-Tex—equivalent to Artex—the powdered paint additive that is irrevocably associated with bad taste and cheap accommodation ('great for rentals!' a current promotion chimes). His colours usually exclude anything earthy or natural; this painting is somewhat demure, as one of Halley's later trademarks is using brightly coloured artificial paints like Day-Glo. Halley also works through various production modes, beginning many paintings with a sketch on a computer, following this with a small hand-painted study on paper, which is used by assistants to produce the full-scale work. Painting is modular here, arranged rather than composed. Halley has remained focussed on this mode of making for over thirty years.

It's difficult to measure now how severely conceived and received was Halley's *volte-face* against the sacred cows of abstract painting. Many artists found his work unbearably cynical. In the late 1980s, Halley was notorious and shocking. He cited French critical theory in his writings ('simulacra' was a new word for us, as was 'pastiche' and 'Baudrillard'). But now, of course, Halley's adoption of an armature of theory to forge a critical position for painting seems no more (or less) than a prescient internalisation of the big lessons of postmodernism: mechanical reproduction, foreclosure of art as a practice of individual development and the 'will to create'. In addition it opposes the tradition (and continuing practice) of art as a spiritual endeavour. What seems significant about this moment in retrospect—and Halley's role in it—is the extraordinary thrill of an essentially dilettante use of theory conjoined with an *idea* of political engagement and a retooling of the language of high culture. Cheap! Weighty! Halley remains an important touchstone, model, paradigm, and his work keeps producing this reminder.

**Born New York, 1953.
Lives and works in New York.**

AG

Richard Kirwan

'Depth of Field' 2011
Acrylic paint on canvas
168.2 × 137.7 cm

Depth of Field utilises the 'asterisk' motif which has formed part of Richard Kirwan's practice since 1992. In a notable early work, *Economy of Meaning* 1995, he utilised a uniform background; here the stencilled asterisk motif is repeated across the canvas in a series of alternating bands of cerulean blue and black. The use of stencilling, allied to the carefully measured layout and the solid, even application of paint, are evidence of Kirwan's impersonal technique. However, whereas earlier works used rollers to apply the paint, here the colours are applied with broad brushes. A visual oscillation is created in different ways; the modified shades of blue, which are not consistent between each band of colour, create such an oscillation, but so does the staggered effect of each row of asterisks: those on the black bands are indented slightly from the edge, whereas those on the blue bands are cut off by the edges of the canvas. The alterations in colour and layout create an unstable visual field, even to the extent that the asterisks seem to 'rotate' as one scans the surface.

The asterisk is a particularly ambiguous motif: it can perform a variety of functions, such as indicating footnotes or section breaks in a text. It can also denote the obliteration of text to conceal a person's identity, or to conceal profanity from those of a delicate sensibility. In this instance, the use of the motif as obliterated text has a particularly charged resonance. The modernist visual field, which *Depth of Field* draws upon, repressed—or at least displaced—the verbal. Whether proclaiming modernist painting as 'purely' visual, or stressing the materiality of the surface, the discourse of modernism advocated work which resisted verbal articulation. Kirwan's work engages with this exploration of the visual.

Op art is particularly notable in this respect, since it created unstable dynamic fields which disorientate our field of vision. Op art was condemned, however, for its 'shallowness' and trickery, in contradistinction to the refined visual ambiguities of modernist abstraction. Kirwan's title *Depth of Field* comes into play here: although it connotes camera lens distortion in the depth of field, it also signifies the shallow, ambiguous visual field of modernist abstraction and its accompanying debates. 'Depth' here signifies profundity, which marked the distinction between 'authentic' modernist work and op art trickery. This tension between depth and shallowness, the visual and the verbal, continues to resonate. In the contemporary context of artist's statements and catalogue essays, Kirwan's work engages with the visual field in order to suggest its capacity to communicate on a different register.

**Born Southampton, 1969.
Lives and works in London.**

SM

Tim Head

‘Continuous Electronic Surveillance’ 1989
Acrylic paint on canvas
198 × 320 cm

The practice of painting takes no precedence in the work of Tim Head; instead it is one method amongst others, comprising installations, photography and sculpture. *Continuous Electronic Surveillance* follows on from the sequence of paintings which Head had commenced in 1986. Initially, these had evinced a marked interest towards mutated organic forms. *Cow Mutations* 1986 was based upon the designs from milk cartons. Related to these concerns during the 1980s, Head took a particular interest in the banal, ubiquitous machine-made forms and embossed designs which are found on packaging and other disposable items. The motif utilised in *Continuous Electronic Surveillance* derives from the patterns found inside payslips and envelopes containing confidential information. Head has utilised this design and applied it to the ‘all-over’ characteristic of decorative abstraction, although the dead-pan execution is more characteristically ‘pop’ (one thinks particularly of the early works of Roy Lichtenstein, which borrowed imagery from catalogues and advertisements). Head’s work, however, does not share Lichtenstein’s benign fascination with the products of consumer abundance. He intimates the closed-off circuits of surveillance and control, becoming increasingly widespread in Western democracies, where our everyday activities are tracked and logged under the guise of ‘security’ and ‘freedom’. A further point needs to be made here: the designs which are printed inside payslips are purposely designed to obscure vision, blocking access to what is inside. The designs turn the very notion of the decorative, or decoration, on its head. *Continuous Electronic Surveillance* finds a slightly earlier resonance in Head’s installation of barcodes at the Tate in 1982. Since barcodes can only be read by a machine, they are effectively an ‘alien’ sign-system. This ‘alien’ system of signification resonates with Jean Baudrillard’s theory of the ‘hyper-real’, an autonomous signifying system which no longer bears any direct relation to the real. Baudrillard’s ideas found currency in the 1980s artworld, and Head’s work, utilising designs for the purposes of closed-off circuits of signification, may be profitably understood within such a context.

**Born London, 1946.
Lives and works in London.**

SM

Alex Hubbard

'Horse Camp No.1' 2010
Acrylic paint, enamel, resin and
fibreglass on canvas
193 × 153 cm

In 1972, Leo Steinberg coined the phrase 'the flatbed picture plane' in response to the early works of Robert Rauschenberg and Jasper Johns. The 'flatbed' evoked a horizontal, rather than a vertical visual field, and it articulated a pictorial space which was no longer primarily visual, but instead a receptacle for objects, data and information. Such a conception of the picture plane allowed not only for a different mode of apprehension on the part of the viewer, but it also articulated different procedures for art-making. Painting could involve actions performed upon or against the surface, or objects incorporated into that surface. More broadly, actions and procedures themselves could now be legitimate *modus operandi*. It is into this more expansive field of activity, opened up by abstraction's dispersal in the 1960s, that Alex Hubbard's work may be profitably situated. His video pieces *The Collapse of the Expanded Field I–III* 2007 exemplify his triangulation of painting, performance and video.

Horse Camp No.1 is therefore produced within this nexus of video/performance pieces. The painterly 'action' or gesture is transmuted into absurdist or destructive performances, utilising cars or other madcap self-destructive machines. These contingent procedures find their way into his paintings. *Horse Camp No.1* treats the picture surface as the kind of receptacle described by Steinberg, and is worked horizontally. The work has an acrylic base layer. This is covered with a stencil motif borrowed from the Memphis Group design house from the 1980s. The 'C'-shaped motif, which is sprayed through a stencil, repeats insistently but haphazardly across the surface; this notion of contingency extends to the motif itself, which breaks up into smaller pieces, perhaps as the stencil wears out through repeated usage. A layer of fibreglass is added, and coloured resin is trowelled into the fibreglass, creating a veil that partially obscures the stencilled motif (this can be seen in the bottom right-hand corner). The procedure does more than simply acknowledge the physicality of the work's surface, but shifts the emphasis upon action, the contingencies of 'doing' and 'making'. The picture surface is acted upon by the artist's gestures, spraying, mixing resin or trowelling.

Unlike his video works, however, which tend towards dissolution or destruction, *Horse Camp No.1* has a sense of relative permanence, a sense of actions and gestures congealed into a stable physical artefact.

**Born Toledo, Oregon, 1975.
Lives and works in New York.**

SM

Jeremy Moon

'5/73' 1973
Oil paint on canvas
153 × 71.1 cm

Jeremy Moon's work often utilises grids as a means of exploring the interrelationship between form and colour. *5/73* is characteristic of these concerns, although the work needs to be seen within the context of his later paintings. From the early 1970s until his untimely death in November 1973, Moon had begun to explore irregular or 'chopped-up' configurations of grid structures, creating subtle structural ambiguities. *5/73* takes on such an irregular structure: the grid is skewed slightly, but nonetheless creates an asymmetric harmony. The composition suggests a web or lattice: two slanted vertical elements are connected by shorter 'arms' which branch out at varying angles, suggesting the structure's continuity beyond the picture surface.

The work engages specifically with the relationship between positive and negative space. The yellow/orange armature appears to function here as a positive element set against a neutral white background. However, the painting also suggests the possibility of reading the structure as a series of 'cracks' peering through the white ground. This latter relation is suggested more explicitly by a succeeding work, *6/73,* which uses the same configuration, albeit with turquoise blue in place of white. The use of turquoise pushes the ground forward, compelling the viewer to read the figure–ground relationship as the inverse of *5/73*. It is precisely this capacity of colour to dynamically alter the composition that led Moon to focus so persistently on such pictorial problems. The explicit engagement with spatial ambiguities and pictorial structure relates Moon to the works of Frank Stella, who exhibited in London in 1964 and 1966, and with Kenneth Noland, who exhibited in London in 1963 and 1965. Moon shared something of Noland's concern with colour relations, although unlike Noland's 'ready-made' targets and chevrons, Moon demonstrated a sustained interest in developing irregular forms of his own design. Despite the shared interest in pictorial structure, Moon's compositions are not as overtly aggressive as Stella's, adopting less astringent colours.

5/73 also relates to contemporary modernist sculpture: it does so by evoking the kind of 'optical' structures aimed for by artists such as Anthony Caro.

At the historical point where sculpture sought to free itself from its materiality, painting simultaneously asserted its objectness. Modernist painting and sculpture thus found themselves intertwined. Moon also worked in sculpture; a related work *3D 1 72* is a floor-based piece which utilises a similar structure to *5/73*. The painted slabs laid upon the floor are punctuated by negative space, making more explicit the 'cracks' suggested in *6/73*. Works such as *5/73* demonstrate that the modernist engagement with issues such as 'opticality' and 'objecthood' was not specific to any one medium, but part of a broader visual enterprise which encompassed different media.

**Born Cheshire, 1934, died 1973.
Lived and worked in London.**

SM

Andy Warhol

'Eggs' 1982
Acrylic paint and silk-screen
print on canvas
228.6 × 177.8 cm

[1]
Bob Nickas, 'Andy Warhol's
Rorschach Test', *Arts Magazine*,
October 1986.

When Andy Warhol was included in a 1986 exhibition, *Tableaux Abstraits*, where two of his 'Rorschach' paintings were seen alongside works by John M Armleder, Imi Knoebel, Sherrie Levine, Olivier Mosset and Blinky Palermo, he was asked if he was going to be an abstract painter from then on. Warhol's tendency was to agree with the observations of most of his interviewers, and he laconically replied, 'Well, maybe ... yeah.' [1] With the 'Oxidation' and 'Shadows' paintings of 1978, Warhol had introduced abstraction into a body of work that was almost wholly image-based and figurative. Even if Warhol's notion of 'serious painting' had been associated with the abstract expressionists of the 1950s—the period from which he emerged, first as an illustrator and then as a painter—his engagement with abstraction remained firmly rooted within representation and, as it had been since the early 1960s, in repetition's power to disorient vision. One could certainly argue that once Warhol discovered the silkscreen, he became one of the preeminent grid painters of the 1960s. In the 'Crosses' that he painted in 1981, the objects are recognisable as such, whether arranged in rows or in radiant patterns, and yet the images also register as grids and as all-over compositions. This is true of the 'Eggs' series that he painted a year later. As with the iconic shape of the cross, the ovoid form is recognisable to us from nature and the everyday; its repetition, random dispersal and isolation on a dark ground, however, carries it into the realm of the abstract, albeit a pop-inflected abstraction. Warhol has it both ways, and not only in terms of picture-making, but also when we consider the psychological aspect perhaps still at play more than twenty years after his less than heroic beginnings, even having set himself apart from those looming figures of the New York School.

The 'Eggs' series can be seen on the one hand as referring back to Warhol's early days as a commercial illustrator—drawing shoes and butterflies and cats, creating designs for wrapping paper, and so on—and also to the work of painters such as Hans Arp, Myron Stout and Larry Poons. Warhol's production in the early-to-mid 1980s included portraits, self-portraits, appropriations of Edvard Munch and 'Details of Renaissance Paintings', and self-appropriations in the form of more 'Dollar Signs',

'Soup Boxes' and 'Flowers'; in short, business-as-usual. But he followed the 'Eggs' with the 'Rorschach' paintings in 1984—his 'psychological abstractions' — and with the large 'Camouflage' canvases of 1986, his pop Pollock readymades. The artist's forays into abstraction resulted in some of his most ambitious and difficult works, and constitute a kind of business-as-unusual. Among Warhol's later and last work, although he couldn't have known it would be his last at the time, we find evidence of connections to his artistic beginnings. The clusters of pastel-coloured eggs, held in a state of suspended animation against a dark field, provide a banal but resonant image—of the kind on which Warhol built his fame.

Born Pittsburgh, Pennsylvania, 1928, died 1987. Lived and worked in New York.

BN

Tauba Auerbach

'Untitled (fold)' 2011
Acrylic paint on canvas
152.4 × 114.3 cm

Tauba Auerbach's interest is in transporting the viewer, who is always understood as a body in space rather than as someone occupying a fixed position. Her work takes perception—and thus the perceiver—elsewhere. She first came to attention with conceptually based text and typographic pieces, compressing and layering language and numbers, placing the spoken and written word in an abstract visual realm—the first instances of her penchant for, and reconciling of, order and pleasurable disorder. When she turned to painting only a few years ago, her materials changed, as did the status of her objects, but her preoccupations did not. Works on paper, or which appeared in printed form, in books and calendars—things which can be held in the hand and in the mind—were followed by canvases that occupied the space of painting, and its usual support, a white wall that we stand back from, momentarily immobilised. And yet Auerbach insists on an active situation, from the surface out to the gallery-goer, from their eyes and ears, brain and body, surface-to-air.

Auerbach's 2009 exhibition at Deitch Projects in New York was dominated by an enormous, two-person pipe organ, the *Auerglass*, and the artist and her collaborator, Cameron Mesirow, performed a partly improvised musical composition every afternoon. The room was hung with a number of *Fold* and *Crumple* paintings, made with an airbrush, their creasing achieved with an iron. And a number of photographs of static on TV were also on view. The sound of the organ's bellows being inflated like lungs, and air forced through its pipes, provided more than a soundtrack to the exhibition. One could also imagine the sound of the airbrush as pigment was sprayed and sputtered onto the canvas, the hissing of steam from the iron and the crackling of the television screen. (With her *Shatter* paintings, and their images of broken glass, there is an auditory element as well.) The playing of the organ rendered it a kind of musical see-saw, a manual / mechanical instrument which relies on a team of operators. When one considers the art historical associations Auerbach's paintings immediately recall, and the means by which she arrives at various visual effects, her project can be thought of as equally post-industrial and postmodern. The opticality of the *Crumple* paintings refers to printed

halftone dot patterns, and the hazy yet convincing illusionism of the *Fold* paintings, of which *Untitled (fold)* 2011 is exemplary, transform trompe l'oeil into an image for our time. Rather than paint the sky on the ceiling, Auerbach offers a view of atmosphere itself. These paintings hover between two and three dimensionality, fooling the eye, but only until we encounter them in greater proximity. Here, Auerbach wants us to come up close, not to stand at a distance from her work, but to enter into it more fully, with a sense of mutual perplexity and wonder. The paint in these works is a kind of vaporous, fragile accumulation of pigment, the essence of painting on a molecular level.

Born San Francisco, 1981.
Lives and works New York and San Francisco.

BN

Moira Dryer

'The Vanishing Self-Portrait' 1990
Acrylic paint on wood, on tree stump
198.12 × 218.44 cm

[1]
Klaus Ottmann, 'Moira Dryer Interviewed', *Journal of Contemporary Art*, vol.2, no.1, Spring/Summer 1989.

[2]
Dryer's husband, Victor Alzamora, died unexpectedly of a heart attack, only 29 years old, and she had lost her mother when she was a child.

In the early to mid-1980s, what might be termed 'good old-fashioned abstract painting' was just that, something not particularly exciting or vibrant in terms of the currents that were passing through art. Abstraction may not have been in crisis, but it didn't command the urgency that was palpable in and around artists whose work seemed to possess a heightened sense of history, criticality and being-ness: Ross Bleckner, Peter Halley, Sherrie Levine and Philip Taaffe, to name a few from the New York scene. And then, in the late 1980s, Moira Dryer came along with paintings that were accompanied by various props and extra panels, were propped up from the floor, had holes drilled into their wood surface, and were titled in ways that insisted on a reading of these supposedly abstract pictures.

Dryer's paintings have a depth of content—personal and psychological—that gives them as much emotional life as if they were probing and insightful figurative studies: portraits and self-portraits revealing everything from joy to anger to grief, inner states of mind, the high and low tides of our lives. Having come from theatre, where she built props and created sets, Dryer was always struck by the particular energy of the stage before and after the actors appeared there. She came to see her paintings as performers, as being installed in galleries to form a theatrical situation. 'It's almost a criteria for me to feel that a painting is somehow alive and animate', she once said. 'Even in the case of a flat, straightforward painting, for it to feel finished, to be successful, I have to feel that it's alive.'[1] Less than four years after she spoke these words, Dryer had passed away, at the age of 34, leaving behind a modest but influential body of work. In an extremely attenuated career, she managed to make abstraction feel vital again, allowed it to actively participate in a painting dialogue that had seemed to pass it by, particularly as it was ceded to less painterly concerns.

The Vanishing Self-Portrait, painted two years before Dryer's death, may appear even more haunted to us today, with its hazy, vaporous atmosphere, its sense of a painting, and whoever had occupied its seemingly emptied space, as erased. The painting sits poised on a small tree stump, not only connecting art and artifice to nature, but reminding us that art and life are reciprocal, always hanging in the balance. It would be a mistake to see this painting as a negation of painting, as somehow an image of its mourning. Dryer was not invested in probing the 'death of painting'. She was someone deeply touched by the loss of life,[2] and her activity as a painter was to stay connected to painting as an engagement that was very much alive, a way of dealing with what was lost and revelling in what could be held onto. A 1991 painting is emphatic in this respect, with its doubled and reverberating title, *Damage & Desire, Damage & Desire*.

**Born Toronto, 1957, died 1992.
Lived and worked in New York.**

BN

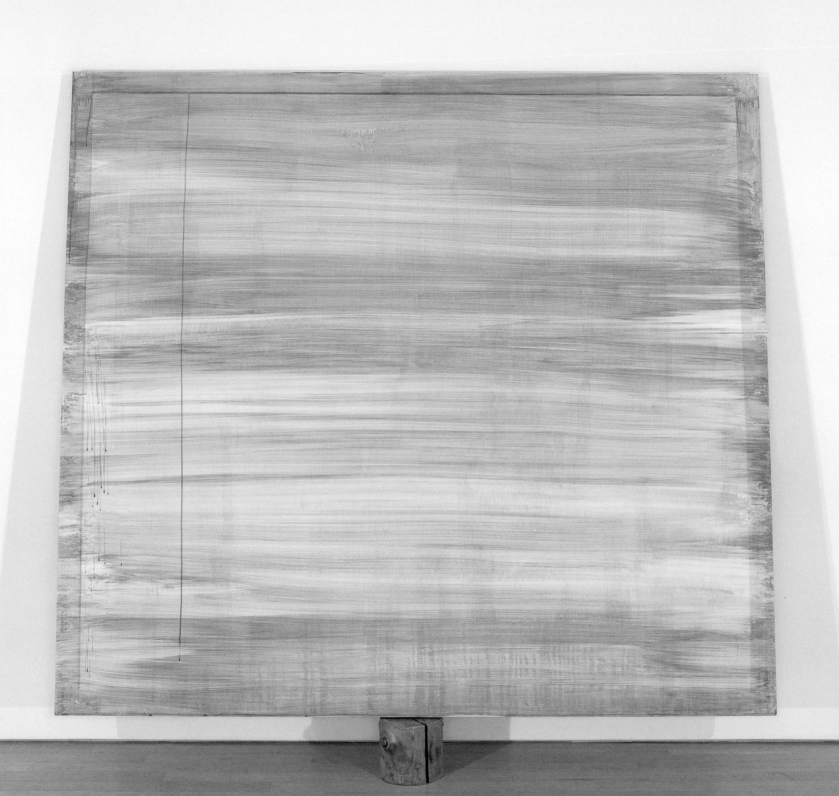

Michelle Grabner

'Big Square Weave' 1998
Enamel paint on board
84 × 84 cm

In *Big Square Weave*, Michelle Grabner adapts the language of abstraction to the context of private space. Modernist abstraction aimed for aesthetic transcendence, signified by the 'decorative', but 'decoration' was considered its inferior counterpart, connoting the 'domestic' and the 'feminine'. *Big Square Weave* operates on both registers: it relates closely to the tradition of modernist painting—one is reminded particularly of Agnes Martin's modulated grids—but it also internalises and renders visible the routines of domestic life. One might claim that Grabner's careful working-up of the pictorial motif internalises the repetitive tasks of household chores and everyday routines. Invocation of the 'domestic' needs to be qualified, however. Unlike the contingencies of the everyday, Grabner's practice sets specific limitations upon her work, giving her a high degree of control over the work's outcome.

Grabner's approach involves the use of various household fabrics and textiles as a stencil to transfer the initial design on to the surface. The motif is therefore generated via an indexical procedure, bearing the direct trace of the household materials used. Having applied the paint through the weave of the fabric, she builds up the motif with enamel paint, which she values for its durable, utilitarian properties. That the pictorial motif is indexical implies randomness or contingency (think, for instance, of the photographic snapshot) but here, an underlying compositional order is intimated by the malleable, web-like structure of the motif. *Big Square Weave* does not evoke an ideal order, but instead betrays a flexible, provisional structure; one can see that the warp and weft of the fabric has been stretched out of shape through usage.

However much it might evoke the domestic or the everyday, *Big Square Weave* affords an aesthetic pleasure which is far from mundane. Despite this, it is an undemonstrative kind of beauty. The variations of enamel against the primed board render the pattern barely visible, not demanding attention but soliciting it modestly, in a manner befitting Grabner's declarations of 'averageness'. This sense of modesty extends to Grabner's scale. Working upon the horizontal surface of the kitchen table, she sets herself against both the verticality of easel painting and the scale and grandeur of much modernist abstraction with its connotations of authority and masculinity.

**Born Oshkosh, Wisconsin, 1962.
Lives and works in Oak Park, Illinois.**

SM

Olivier Mosset

'Yellow Blp' 1987
Acrylic paint on canvas
280 × 140 cm

Of the four artists who comprised the affiliation known as B.M.P.T.—Daniel Buren, Olivier Mosset, Michel Parmentier, Niele Toroni— active briefly in Paris from end of 1966 to the spring of 1968, it is Mosset who has remained the most consistently involved with the practice of painting and the questioning of its status. His passage from the confrontations of B.M.P.T. to the post-everything world in which we find ourselves today, by way of the events of May 1968 and his iconic 'circle' paintings, the proto-appropriations of his 1970s stripes, monochrome canvases, and neo-geo in the mid-to-late 1980s, is marked by an awareness of painting's history, the political dimension of abstraction, and the limits of what can be accomplished with a brush. His position is an existential one, but informed by a healthy sense of humour: since 'the last painting' was made a long time ago, and continues to be made, does it matter if the can of paint is half full or half empty? Mosset might appreciate, but would never himself formulate, the question. Over forty-plus years, his work has been conceptual and comic, equally rigorous and casual, marked by an engaged indifference. All of this is very much in evidence with *Yellow Blp*.

Mosset's 'Blp' paintings (there is also a black on black version) can be seen as larger painted representations of the graphic and sculptural *blps* originally created by Richard Artschwager in the late 1960s. Referencing exclamation points and lozenges, many of the first were modest in size and black, either made of wood or stencilled directly onto walls, and dispersed around galleries, museums and public spaces. Locational works calling ambiguous attention to themselves and their surroundings in relation to art and architecture, the *blps* also implicate the viewer who happens upon them. The *blps* are mischievous performers that have an active sense of play once discovered, and like much of this artist's work they function at a point somewhere between minimal and pop art. Artschwager later produced much larger *blps*, which approximate the scale of proper paintings and are hung where one would expect to see them within an exhibition. While Mosset's 'Blp' paintings share this anarchic spirit of a pop-inflected minimalism, they also register as readymades: as proto-appropriation. The 'blp' joins the circle, the stripe, the monochrome, geometric abstraction, the shaped canvas, and anything already existing within the realm of vernacular forms and motifs that can be redeployed on canvas—or whatever material is chosen—and with or without recourse to paint and brush. In our sense of a work of art as completed by the viewer—here via Artschwager's *blps*, Mosset with his assisted readymade paintings, and Duchamp first of all—there is also the notion of anonymity and the creative act. With the paintings of Mosset, you have the distinct impression that the artist himself, even in the moment of signing them, could imagine them as having been painted by almost anyone else. What is a blip really? A momentary interruption, insignificant, nearly nothing at all.

Born Bern, Switzerland, 1944.
Lives and works in Tucson, Arizona.

BN

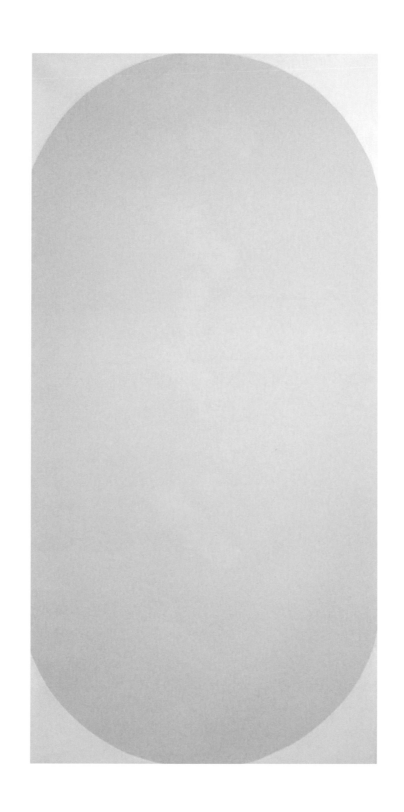

Carl Ostendarp

'Open at the Poles' 1991
Foam and oil paint on canvas
165.1×180.3 cm

[1]
Carl Ostendarp interviewed by
Cora Cohen, *BOMB*, no.37, Fall
1991.

[2]
Telephone conversation with the
author, 12 July 2011.

[3]
Barry Schwabsky, 'Carl Ostendarp',
Arts Magazine, February 1992,
p.59.

If there have been many junctures when painting's death was loudly proclaimed, the late 1980s in New York was one of them. The terminal ailments at that time were particular. They were conditioned by the resurgence of market-oriented expressionist painting, but there was also—remarkably, still—the dead hand of the New York School and its formalist legacy. How do you begin, here? If you were Carl Ostendarp, you'd look for something to do the work for you. *Open at the Poles* belongs to a group of paintings he made over a four or five year period at the beginning of his career when he used expanding urethane foam, a material from the building trade. This got him out of what he had been doing—making serious abstract paintings. Ostendarp made use of the foam's capacity to form its own shape with only a little intervention. 'I'm not sure how it's going to look', he said in an interview at the time. 'I can make it look like a pancake or I can make it look like a big drip ... but it's not like a drawn image'.[1] The readymade aspect of the material shifted his work from labour to choice. And, paradoxically, gave him permission to paint. In these mainly two-colour paintings, establishing the edge between the figure and ground turned out not to be a straightforward filling-in, but a sleight of hand, the production of an illusion. This allowed for other elaborations, such as adding a border on some paintings, which meant he got to choose a third colour (irrational!) and play with what he calls a 'goofy mathematics' he sourced in paintings he was looking at, such as those of Barnett Newman, John Wesley and Ralph Humphrey.[2]

These works are also forays into areas of content that had been precluded from abstract painting for decades. Ostendarp looked for his titles outside the art context. 'Open at the poles' is a phrase from the Edgar Allan Poe novel *The Narrative of Arthur Gordon Pym of Nantucket* 1838, and refers to the widely held pre-modern theory that the earth was hollow. The colours of these paintings drew from the built environment and commercial packaging rather than an artist's palette. And the paintings are quite clearly 'figurative': they are bodies even if they include no details that let you identify which part, and are supported by titles that reference insouciant behaviour and physical activities (*Get Drunk, Anything to Please,*

Limbo and *It's a Shame* are some examples). It's symptomatic of the prohibitions still in place in discussions of abstract art in the early 1990s that not a single critic writing on Ostendarp's foam works went beyond the metaphor of them being skin, or having weight, to naming body parts. *Open at the Poles* quite obviously can be read as a large, nipple-less, and somewhat deflated breast. To identify this now is to call attention to the neutrality needed at the time to locate a productive place for making any paintings at all (one critic wrote then of Ostendarp's works' 'stubborn resistance to signification').[3] Yet, when art is now laden with content, the impassiveness of Ostendarp's work seems equally, and importantly, useful.

**Born Amherst, Massachusetts, 1961.
Lives and works in Ithaca, New York.**

AG

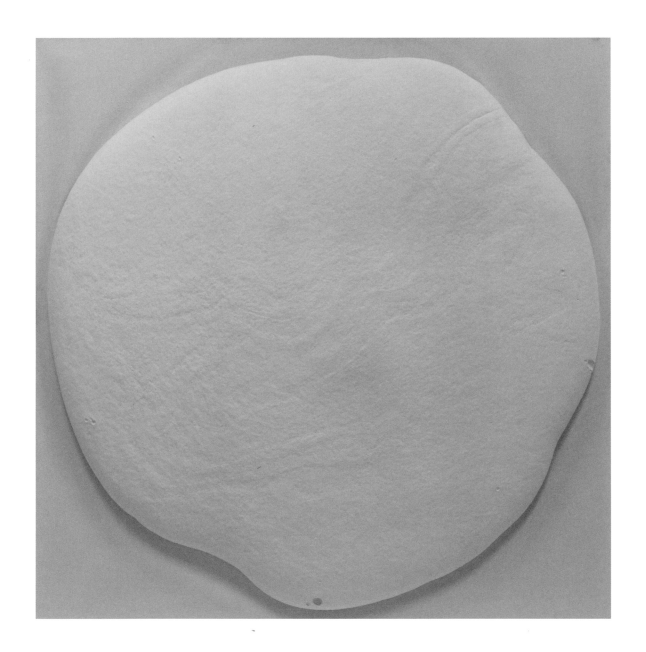

Steven Parrino

'Untitled' 1992
Spray paint on canvas
92 × 92 cm

Steven Parrino's contribution to painting at the very beginning of the 1980s, a period which followed the so-called 'death of painting' and ushered in the return to figuration, was to fully embrace the medium as a lifeless body with which he could have his way. He referred to his position as necrophiliac, and enacted painting's dis-figuration. Working within the most seemingly abstract of images, the monochrome, this was accomplished by a simple but radical move. He would stretch far more canvas than was necessary, with the excess canvas temporarily accumulated behind the stretcher, evenly coat the surface with paint—very often enamel black or metallic silver—and then pull the excess canvas forward to occupy the otherwise uninflected picture plane. Suddenly, the monochrome had sensuous and violent folds of canvas, as if it was drapery or crushed metal.

At the time that Parrino introduced his mis-stretched paintings, many of his peers were enamoured of Warhol as image-maker, relying on silkscreens to deploy and repeat photo-based images, commenting on the newly ascendant consumerism and image world of the 1980s which followed its initial rise in post-war America in the 1950s and 1960s. But Parrino's work looked at Warhol the painter and anti-painter, and his project recalled the pop artist's monochrome panels—he referred to them as 'the blanks'—which accompanied his 'Race Riot' and 'Death and Disaster' paintings, as well as his 'Silver Clouds', the helium-filled pillows which hovered above the gallery, and announced his supposed retirement from painting in the mid-1960s. Parrino's mis-stretched monochromes could be seen as the deflated version of one of those pillows, or as the wreckage pictured in one of Warhol's car crashes, and while they mostly had affinities with American painting of the time—with the black and metallic canvases of Frank Stella, and the action painting of Jackson Pollock—there are also European connections to be made, though more readily with hindsight. There are Blinky Palermo's *Stoffbilder* pictures of the late 1960s to consider, and it's tempting to see in the folds of Parrino's canvases an extreme close-up of the shiny gown in Gerhard Richter's *Woman Descending a Staircase* 1965.

The contradictions in Parrino's abstract imagery reflect this artist's attraction to the reserve of a cool sensibility and the kineticism of chaos, and his paintings can be alternately minimal and baroque, alive and dead, situated between rigor and mortis—like painting itself. This is certainly true for Parrino's *Untitled* 1992, a work which is simultaneously icy and agitated, composed and discordant, with a reflective surface surrounded by raw canvas, seemingly hard and soft at the same time. Parrino's equal interest in refined culture (abstract and monochrome painting) and in its lower depths (bondage and burlesque) is clearly evident here. *Untitled* 1992 can be seen to perform, as if a stripper writhed on stage to the Lydia Lunch song *I Twist, You Shout*.

**Born New York, 1958, died 2005.
Lived and worked in New York.**

BN

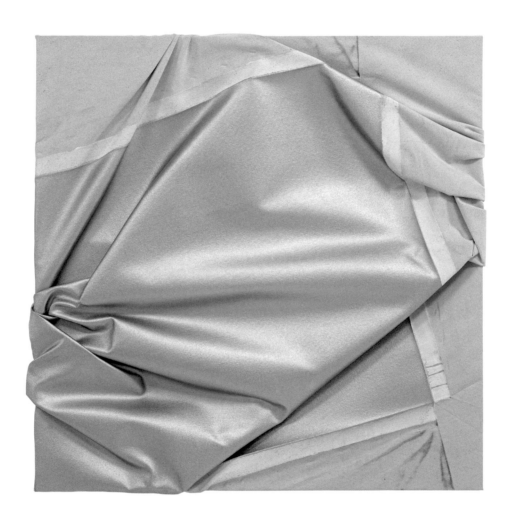

Bernard Frize

'Suite Segond 100 No. 3' 1980
Household paint on canvas
130 × 162 cm

[1]
Bernard Frize, cited in 'Work in Process,' *Artforum*, February 2003.

I am interested in works that use the disjunction between 'before' and 'after' as a device: this gap becomes a source of fiction and a surprise.
Bernard Frize [1]

This painting, like most of Bernard Frize's work, derives from the principle that once the artist has decided on a central guiding idea or premise, he follows a relatively straightforward procedure, although this is not without unexpected results. In this instance, the work could be said to have 'painted itself' with little intervention from the artist. Frize opened the lids of an array of pots of paint in his studio. As the paints dried through exposure to the air, a thin film formed on the surface. Gently peeling off each coloured skin, Frize affixed these coloured discs to the canvas; since the underside of the skin had yet to dry, this functioned as an adhesive. The discs of colour are therefore ready-made, straight from the can. The work lays itself bare allowing viewers to re-imagine the work's production. Temporality plays an important role in Frize's work, although in this instance, the temporality in play is empty time, literally paint drying. While this process took place over a period of several weeks, Frize was free to do something else. When this work was made, the artist was still a 'Sunday painter', working only at weekends, with a day job during the week. However, the procedure allows for other possibilities: that one might go out, read, do the ironing, perhaps do nothing. There is a suggestion of Marcel Duchamp's insouciant disregard for work here.

Frize's attitude towards painting is Duchampian in other respects: he describes his painterly procedures as 'absurd,' 'ridiculous', even 'idiotic.' This is partly because the logical procedures generate unforeseen chance effects. We see this in the slightly ragged edges of the coloured discs as they overlap and abut; creases and bubbles created from affixing the colours to the canvas rupture the smoothness of the surface. But more broadly, the very structure of the work, which is contingent upon its central generating principle, necessitates procedures which may well be 'idiotic' or 'absurd'.

Frize's generative concepts, however crafty, are not lofty or elevated; he has stressed that his paintings ought not to transcend anything we might encounter in everyday life. This everyday quality is reinforced by the use of the technique of collage. Collage is an art of the discarded and the ephemeral, its materials sifted from the flux of everyday experience. Here, however, Frize has scavenged the waste products of his own studio; the practice of painting has thus internalised the principle of collage, demonstrating that painting is placed within a nexus of overlapping processes and procedures.

**Born Saint-Mandé, France, 1954.
Lives and works in Paris and Berlin.**

SM

Ruth Root

'Untitled' 2004
Enamel paint on aluminium
121.9 × 106.7 cm

[1]
See Yve-Alain Bois, 'Ellsworth Kelly in France: Anti-Composition in Its Many Guises,' in *Ellsworth Kelly: The Years in France, 1948–54*, National Gallery of Art, Washington DC 1992, pp.9–36.

[2]
Bob Nickas, 'Ruth Root,' *Painting Abstraction: New Elements of Abstract Painting*, London and New York 2009, p.154.

Ruth Root's paintings are deceptively plain. I'd like to argue that this is their salient feature, and that it allows for them to seem as if they're in transit from one realm of culture to another. So even if one sees them on the white walls of a gallery, they seem like they're on their way to a modernist caravan park, possibly coming from Apple's design lab, but stopping to do research in one of Gerrit Rietveld's interiors. This is abstract painting at the crossroads of art history and popular culture, and it represents a new kind of vision cultivated in the slipstream of screen-based media.

Symptomatic of this situation is the lack of a critical language that can deal with paintings like those of Ruth Root. Essays and reviews of her work situate it next to precursors; the list is long—Piet Mondrian, Josef Albers, Sonia Delaunay, Hans Hofmann, Ellsworth Kelly, Richard Tuttle, Imi Knoebel, Blinky Palermo, Olivier Mosset, Mary Heilmann—and absurd. Let's take just one of the comparisons and address it in a little depth. Kelly seems the best, because of the fundamental conjunction of shape and colour in his work that Root shares. But very quickly the comparison falls apart. Root hand-paints her works with a sponge brush and sands them down for a smooth finish, Kelly usually uses a roller. Kelly's shapes follow known geometric shapes for the most part and reference the natural world. Root's geometry has to do with using straight lines and flat expanses of colour, but her shapes are unique and idiosyncratic, and make reference to the way geometry plays out in the design of useful things (even though her paintings don't do or make anything in a practical sense). Kelly employs chance to construct his patterns, and thus, as Yve-Alain Bois has argued, his work is a critique of the tradition of abstract art, and 'anti-compositional'. [1] Root's paintings are in conversation with the phenomenal engagements of post-minimalist painting: they are very thin and adhere to the wall with little shadow. Although you expect them to be made of multiple layers, they're not, and therefore they assert themselves as images rather than objects. 'The wall', Root has said, 'is the negative space, and functions as the rest of the canvas.' [2] For Root, history isn't something to negate, it's to absorb.

As I have suggested, Root's frame is larger than the tradition of geometric abstraction, or painting's 'expanded field'—unless we take the latter to signify a cultural rather than a spatial axis. The point that needs reiteration is that Root's work, her visual innovations, ignores and therefore productively undermines old genealogies and associations. Sometimes the loss outweighs the gain, but not in Root's case.

Born Chicago, 1967.
Lives and works in New York.

AG

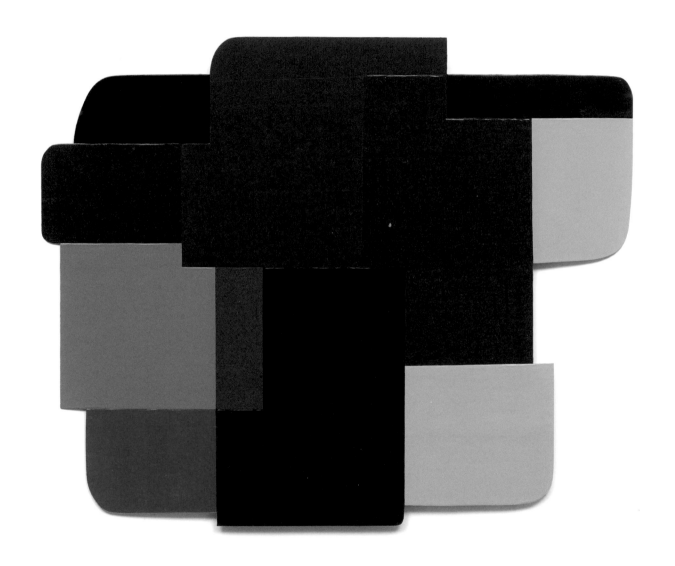

Cheyney Thompson

'Chronochrome set 3' 2010
Oil paint on canvas
190.5 × 330 cm

[1]
Cheyney Thompson, Press
Release: *Motifs, /Robert/, Paul
de Casteljau, Socles, Ménarches,
Chronochromes*, Sutton Lane,
Brussels, 9 September–
23 October. 2010.

[2]
Most recently in David Joselit,
'Signal Processing', *Artforum*,
Summer 2011, p.360; also 'Painting
Beside Itself', *October*, no.130,
Fall 2009, pp.125–34 and most
extensively in 'Blanks and Noise:
On Cheyney Thompson', *Texte
zur Kunst*, no.75, March 2010.

Cheyney Thompson's metier is the gallery installation, and painting is only one element of this. Would it be a misrepresentation to show one of Thompson's paintings without his work in other media? It has certainly been done before and he has no doubt planned a level of transitivity into all his works. Paintings from the *Chronochrome* series have been shown in Paris, New York and Berlin, but in combination with other works like his *Socles* (pedestals in unusual geometric shapes), works on paper under the title of */Robert/* or *Robert Macaire*, and an array of other objects with such titles as *Ménarches*, *Paul de Casteljau* and *Motifs*.[1] Two concepts, not necessarily complementary, drive Thompson's installations: the copy and the archive.

In the *Chronochrome* series—a wordplay on that pinnacle of modernist abstraction, the monochrome—Thompson proceeds with the work of painting via a suite of elaborate systems. There is the time-grid, where the paint-marks reveal when work stopped and started. This is there to emphasise the labour of the painter, mechanical, unregulated and cheap. There is the 'subject matter' of the image, a digital scan of the linen canvas, processed into numeric information based on light striking its empty surface and producing high-, mid- and low-lights out of the material support—a baseline of sorts. This information is mapped onto another conceptual framework, the colour system rationalised at the turn of the twentieth century by American artist and inventor Albert Munsell, who divided colour into the components hue, value and saturation (a system still employed in industry to standardise and identify colours across materials). The resulting image—painted by hand—is not just a copy, but a copy informed by various conventions of producing abstract paintings: colour as a modernist obsession, systems painting per se, and conceptual art's apparently rational procedures that in some cases tip over into something else. Sol LeWitt's quip that 'Conceptual artists are mystics rather than rationalists' springs to mind, but doesn't fit squarely here. There is also the size and layout of each painting. Thompson explains that the heights of the paintings in this series are all the same, which is the standard size of rolled canvas. But the widths are unique, and this signals a 'fundamentally

arbitrary cut into an industrial loom's more or less infinite capacity for production'. *Chronochrome set 3* is made up of three separate canvases of different sizes, the central one notably slim and limit-testing: a cut, a 'zip', a post-minimalist painting-object, it's as narrow as any painting can be.

The critic David Joselit has written several times about Thompson and a handful of other recent painters, that their work should be seen as 'screens' and in relation to networks of information.[2] Painting, he argues, is now transmission of information rather than production of meaning. The referent is the internet, and a single painting is like the terminal: just a point of access to vast and uneven systems of knowledge. Thompson's work is perhaps more critical than this statement implies, especially in relation to his interest in archives. He is voracious and his over-determined processes produce halls of mirrors. This is some serious play.

Born Baton Rouge, Louisiana, 1975.
Lives and works in Brooklyn, New York.

AG

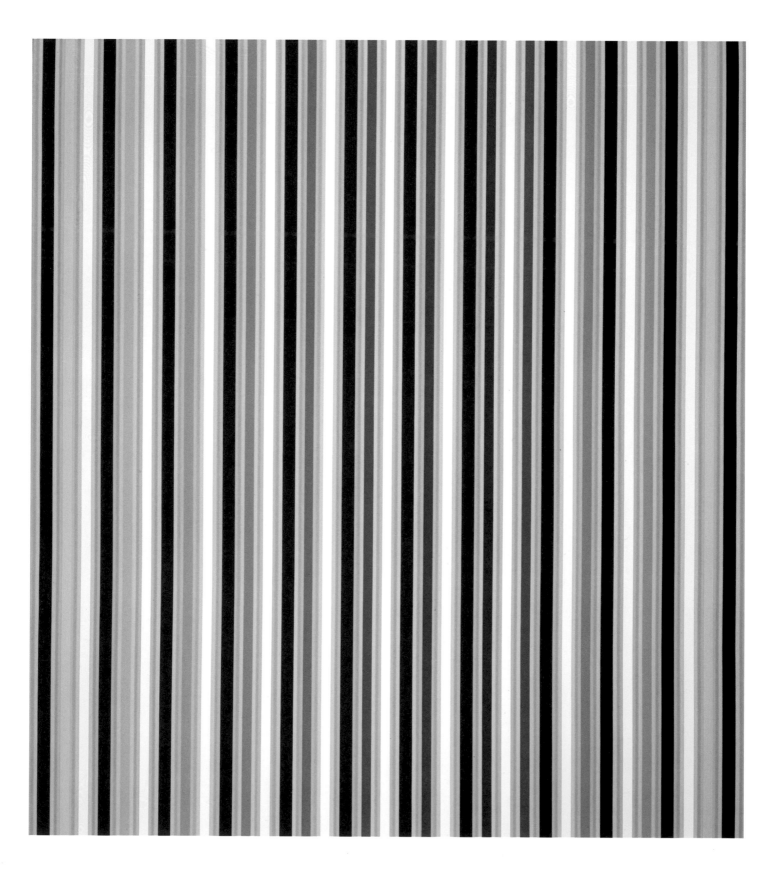

Sean Scully

'East Coast Light 2' 1973
Acrylic paint on canvas
215 × 243.8 cm

[1]
As quoted in David Carrier,
Sean Scully, London and
New York 2004, p.68.

[2]
Ibid., p.30.

[3]
Ibid., p.38.

Sean Scully painted *East Coast Light 2* during a fellowship year he spent at Harvard University, where he was given a studio and few responsibilities other than doing his work. Living there was a stark contrast to the cold and gritty experience of South London where he grew up after the age of four, or studying at art school in Croydon and Newcastle-upon-Tyne. Scully explained that in the United States, 'The roads were wide, the light gorgeous.' [1] During that year, Scully began to visit galleries in New York (Boston was then a provincial city for contemporary art), which paved the way for his move there from London in 1975.

East Coast Light 2 dates from a highly experimental period in Scully's career, between his adoption of stripes in the late 1960s, and 1981, the year when he adopted a signature motif of thin black and grey stripes that would occupy him for most of the 1980s (writer David Carrier argues that Scully 'found his style' in 1981, and with those paintings, 'let us into his art'). [2] Whilst at Harvard, Scully started to use acrylic paint, and worked through numerous modes of putting paint down, from thin and illusionistically to thick and materially. He made shaped canvases and experimented with materials, in one painting he wove fabric over a grid-shaped armature. Nonetheless, in all of these works the unifying theme was stripes. In *East Coast Light 2*, they appear densely woven and induce one to look past the surface and into an unfathomable depth. This is the result of Scully's having used the darkest colour at the bottom, and having painted 'shadows' beneath the stripes. These are masterstrokes of stagecraft that importantly distinguish Scully's interest in the stripe from that of Frank Stella, who deracinated it, made it automatic, material, and of painting's surface. The shape of *East Coast Light 2* is its most interesting feature: like the bottom of a necktie, it's a hybrid between a rectangle and a diamond. It initiates the reason for making the stripes diagonal (relating, like Stella did, the interior pattern with the shape of the painting), but this only being half the shape, Scully's painting is eccentric, unique and illogical.

Scully is an artist cut from Romantic cloth, and this is a relatively rare thing these days. He does not use assistants. He has sought, and arguably achieved, a signature style. His work is abstract but connected to nature: 'Being an artist is simply an attempt to imitate and if possible rival the natural world', he states. [3] This painting is not generic but has a referent: the extraordinary winter light that can be found when looking at the Charles River in Cambridge, Massachusetts, with snow falling. Scully's work makes an argument for painting's rootedness rather than its dislocation—or, given his own peripatetic life and the distance he has travelled from his roots in working-class Ireland, it shores up, and compensates for, such deprivations as they are experienced.

Born Dublin, 1945.
Lives and works New York, Barcelona and Munich.

AG

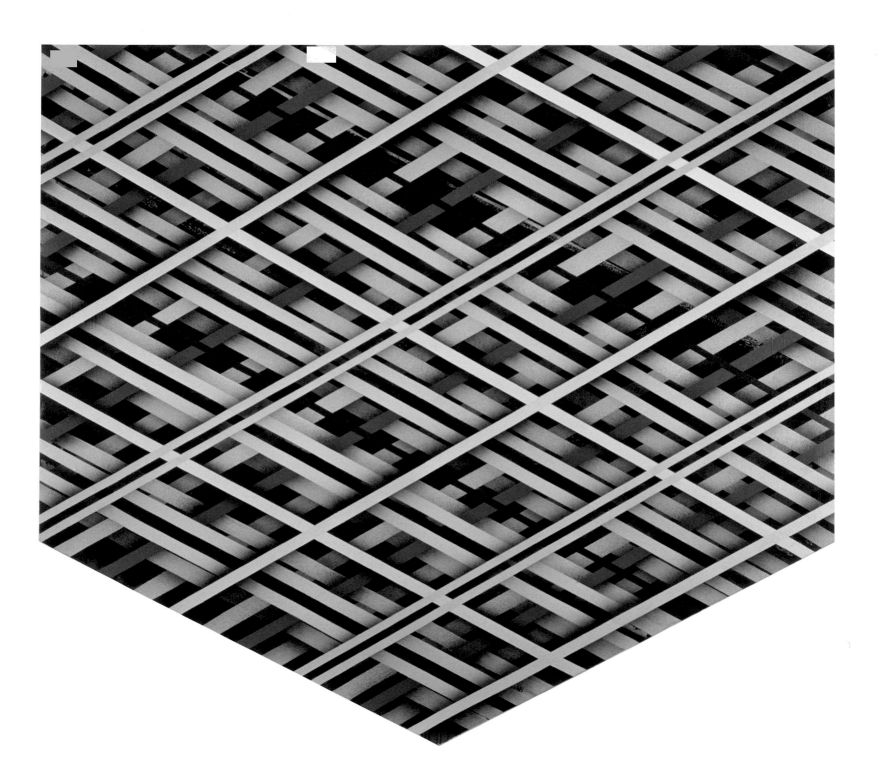

Jane Harris

'Flirt' 2009
Oil paint on canvas
107 × 230 cm

Jane Harris's work operates at the interface between abstraction and representation. Her work even suggests that the very terms themselves are insufficient. The artist herself has claimed that she dislikes the use of the term 'abstract' in relation to her work, however appealing such a label may initially appear. At first glance, the simplicity of the composition and the sparing use of two closely valued hues suggests the legacy of hard-edge abstraction. Closer inspection, however, reveals the inadequacy of this reading, and this is manifest in a number of respects. Firstly, one should note Harris's use of doubling. Modernist abstraction was often characterised by its compositional singularity, whereas Harris's use of doubled, or perhaps mirrored, forms alters the way in which we look at the canvas.

The two forms have an elliptical shape, one of the recurring motifs of Harris's painting. The ellipse has two focal points: it can be simultaneously two or three-dimensional. This dual experience also manifests itself when we look at the canvas. However much we try, we cannot look at both forms simultaneously; the work resists being taken in at a glance. This dual visual experience is further enhanced by the precision used by Harris to delineate each shape, inviting the viewer to inspect the surface more closely. The two shapes here, which suggest shells or other stylised organic forms, have been helpfully described by the critic Tom Lubbock as invoking the language of heraldry. Specifically, the forms seem to have been 'engrailed', that is, scooped into the surface of the canvas at a shallow angle (whereas forms which protrude convexly are 'invecked'). This lends the work a tactile connotation, further emphasised by the traces of the brush left visible on the surface.

Heraldic imagery is further emphasised by the decorative and ornamental connotations of the two forms. The colours of the surface hint at iridescence and gilding and recall the gold leaf used in *Quattrocento* altarpieces. Harris pays particularly close attention to the edges of the engrailed forms. The edge is the boundary between the form and its surrounding space, inviting us to speculate upon whether or not the edge is intrinsic or extrinsic to the form itself. Similarly, decoration or gilding is thought to be extrinsic to the work of art, but Harris may be said to have elided this distinction, or at least rendered it problematic.

Born Dorset, 1956.
Lives and works in Thiviers, France.

SM

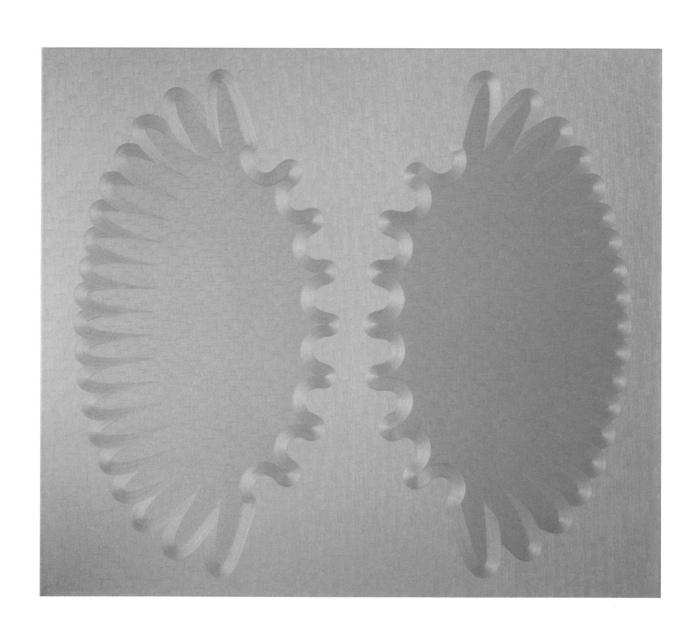

Dan Walsh

'Auditorium' 2008
Acrylic paint on canvas
140 × 228 cm

Auditorium, the painting and its title, offer a way into the work of Dan Walsh, a blueprint of sorts, which is fitting given the architectonic and spatial considerations that his paintings raise from the ground up. An auditorium is most often a public space, one with an audience facing performers or speakers or a spectacle on a stage. For Walsh that stage is painting, its history and its audience, and his work serves both as performer and prop, the setting for the minimal, earnest and at times absurdist plays that he orchestrates and frames. Rather than overstate the theatrical aspect or reading of his work, it should be introduced as directly as the objects and elements that he sets before us from one painting to the next, and which compel us to foreground the act of looking as a space of contemplation. Walsh's paintings are not merely put forward so that we might pleasurably get lost or 'zone out', but so that the artist can enter into a dialogue with himself and his own history. The 'end of the line' that perhaps began with Kasimir Malevich and Ad Reinhardt— and 'the last painting that anyone can make'—reached an open-ended finality with painters such as Peter Halley, Sherrie Levine and Philip Taaffe, all prominently included in the 1986 exhibition *Endgame: Reference and Simulation in Recent Painting and Sculpture*. Twenty-five years on, that exhibition's currents have reached a kind of high tide, and with painting, particularly abstraction, once again on the rise as a questioning self-referential project, it could easily be re-staged. Dan Walsh, along with artists such as Tomma Abts, Tauba Auerbach and Rudolf Stingel, would be worthy of consideration for this 'Last Picture Show'.

With its freely hand-painted grid of blocks, an optical squares-within-squares motif that Walsh has often deployed in recent years, *Auditorium* is both ordered and destabilised. Never relying on tape or a straight edge, Walsh animates his paintings with a slightly wavering line that he may subtly bow. When he paints one colour on top of another and intertwines lines, they are enlivened and given an afterglow or subtle vibration. By hanging his paintings very low to the floor, he places the viewer directly in the picture, and relates the work to the room in which it's shown. The squares in this painting, appearing as if they were twenty-eight miniature Frank Stella's comically

rendered by Philip Guston, have a sense of syncopation that allows the overall image to pulse, drawing the eye in and around them, which is further amplified by the opticality of the painted framing device. For all its formal elegance and reserve and its sober chromatic tones, the painting has a playful personality, and simultaneously focuses and diverts our attention: a perfect metaphor for Walsh's activity in the studio whenever he stands before the canvas, brush in hand. The studio, after all, is its own auditorium, one where the artist rehearses his lines in order to perform.

**Born Philadelphia, Pennsylvania, 1960.
Lives and works New York.**

BN

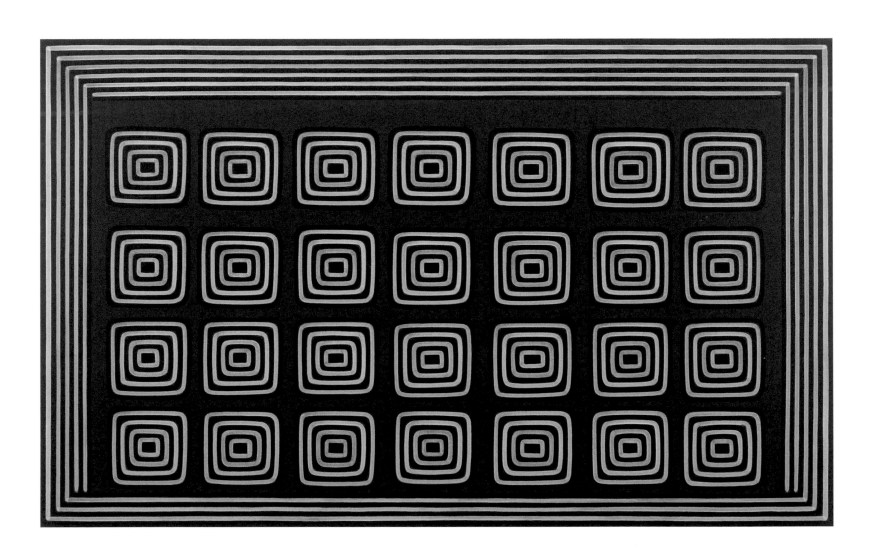

Daniel Sturgis

‘No Other Home’ 2011
Acrylic paint on canvas
128 × 213 cm

[1]
Leo Stenberg, 'Other Criteria', in *Other Criteria: Confrontations with Twentieth-Century Art*, London and New York 1972, p.90.

[2]
Takashi Murakami, 'Superflat Trilogy: Greetings, You Are Alive', in *Little Boy: The Arts of Japan's Exploding Subculture*, exh. cat., New York and New Haven 2005, p.161.

Daniel Sturgis's paintings allude to the cycles of utopianism in early twentieth-century modernism, the aesthetic idealism in mid-twentieth-century expressionism, and the long backlash that has sustained itself against these figures of tradition since the late 1950s. They are performed, if you can use such a metaphor for painting, through these lenses, but they are not about historicism, or foreclosure, or blind beginnings. His is neither a defence nor an embrace, but an argument that painting is a detailed and flexible language able to propose ideas and enact provisional answers.

No Other Home is from a recent series Sturgis calls his 'stacked paintings'. Other painters have taken the painting off the wall and into space itself, but in Sturgis's work the stack is virtual. More than that: in *No Other Home* it's an impossible stack, all floating layers and little gravity. The painting's geometries don't work in Euclidean space, something you might sense from a distance but that is provable upon looking closely. For example, the two black-and-white chequered layers seem to be exactly the same, but they move out of alignment across the width of the painting. Realising the misalignment is like seeing an after-image of a hidden process; an apparently flat layer in fact has a warp, or a bend. Another incongruence—an impossibility of sorts—are the four small blue dots situated as if on top of three of the stacked planes. They intervene in what is an already complicated spatiality, asserting gravity, making edges into surfaces, and thus a planar space into a three-dimensional one. They are not decorative dots, rather they have a strong anthropomorphic quality, as if they might suddenly make some noise, or roll. Where is this place? What *home* is it? There is also a grid of grey and brown squares at the back-most layer. It lines up with the top and left sides of the painting and thereby establishes itself as a ground. Reminiscent of the grey-and-white grid at the base of Photoshop documents and applications like the map on the iPhone, you treat it as a base, but it is a provisional ground, a placeholder. Nonetheless, this layer exceeds its metaphor when you find it wraps halfway around the edge of the canvas. It is 'real', after all. This is a painting of contradictions. It has a 'finish' but is full of open ends.

It looks fast but in fact has been made slowly. It draws its visuality from all over the history of painting and design and technology.

Sturgis's work provokes precise questions about flatness, in both its visual and philosophical dimensions. Flatness was meant to belong to painting in its modernist moment, but in a postmodern one it references a cultural horizontal. We've been in the latter place for a while: Leo Steinberg wrote in the late 1960s of the 'flat bed picture plane' as 'a pictorial surface that let the world in again'.[1] In the early 2000s Takashi Murakami proposed 'superflatness' as a total embrace of subcultures, what he called 'the work of monsters'.[2] Flatness in Sturgis's paintings, I'd argue, is situated across both digital and analogue realms, which is, in fact, closer to what the world is like.

Born London, 1966.
Lives and works in London.

AG

Heimo Zobernig

'Untitled' 2008
Acrylic paint and tape on canvas
150 × 150 cm

Heimo Zobernig's work is structured around two of the central modes of twentieth-century modernist painting: the grid and the monochrome. Starting in 2000, Zobernig initiated a series of paintings derived from the diamond-shaped canvases of Piet Mondrian, inflected through the work of Australian artist Ian Burn, whose *Yellow Blue Equivalence* was seen by the artist in 2004. Burn's work consisted of a horizontally oriented yellow canvas punctuated by parallel blue lines which run across the full width of the canvas. Like Burn, the grid in Zobernig's work is neither pristine nor autonomous, but refracted through its subsequent re-interpretations and re-inscriptions in artistic practice. There is no medium-specific purity to Zobernig's paintings: instead, they are produced within a nexus of video, installation and sculpture.

The monochrome signifies the utopian, revolutionary ideals of modernism, although Zobernig's use of blue also suggests its capacity for aesthetic transcendence. Blue also signifies value. While the rarity of ultramarine pigment signified this in old master paintings, masterpieces of modern art are today blue-chip investments. (This overlapping of art and value is evident in another work by Zobernig where diamond-shaped grids were covered with Swarovsky crystals.) The blue used in *Untitled* has more specific connotations. It is both reminiscent of the backdrop to Matisse's *Large Nude* 1935 and is painted on a specific cloth—the chroma-key fabric used in video compositing. Chroma-key fabric uses blue because of its rare occurrence in flesh tones, leaving foreground footage unaffected when the blue is removed from the shot.

The blue fabric constitutes the ground of the painting, which is often left exposed in Zobernig's work. He paints over the blue fabric in white acrylic and in this particular work uses white tape directly upon the surface, in the manner of Mondrian's late compositions. The relationship between figure and ground is confounded. Indeed it is difficult for the viewer to discern which parts are superimposed and which have been 'revealed' by the process of masking. In addition to this tension between figure and ground, Zobernig exploits the tension between the order provided by the grid and the free play of the superimposed motif. Whereas the grid connotes order

and detachment, the curvilinear forms signify the autonomy of the artist's intuitive gesture.

There is a further ambiguity to this chroma-key ground: it is a space which is neither literal nor transcendent. Instead it exists *in potentia*, a space which will only subsequently be 'filled in'. Zobernig's video works also make use of this process in conjunction with his own body. The movement of the lines against the grid might be seen as both the index of the painter's gesture and as analogous to the movement of the body through space. *Untitled* presents the modernist grid/monochrome as a phenomenon situated in our contemporary multimedia environment, albeit still capable of yielding new avenues for investigation.

**Born Mauthen, Austria, 1958.
Lives in works in Vienna.**

SM

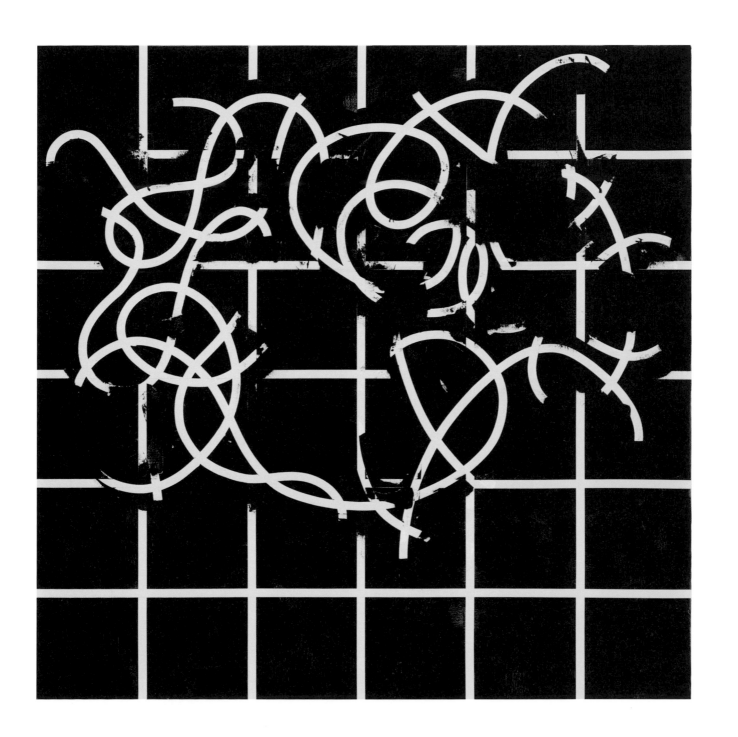

List of exhibited works

Page 19
Myron Stout
Untitled No.2 1956
Oil paint on canvas
51.1 × 35.7 cm
Whitney Museum of American Art,
New York
Gift of Charles H. Carpenter Jr.
Image: © Estate of Myron Stout,
Joan Washburn Gallery, New York

Myron Stout
Untitled (Wind Borne Egg) 1959–1980
Oil paint on canvas
66 × 50.8 cm
Whitney Museum of American Art,
New York. Purchased, with funds from
the Mrs. Percy Uris Purchase Fund

Page 21
Robert Ryman
Untitled 1965
Oil paint on canvas
28.3 × 28.3 cm
Mondstudio Collection on permanent
loan to the Museum Wiesbaden
Image: © The artist.
All rights reserved, DACS 2011

Page 23
Gerhard Richter
Two Greys Juxtaposed 1966
(Zwei Grau Nebeneinander)
Oil paint on canvas
200.4 × 150 cm
Courtesy of the Froehlich Collection,
Stuttgart
Image: © The artist.
Courtesy of the Froehlich Collection,
Stuttgart
(Tate St Ives only)

Page 25
Imi Knoebel
Black Square on Buffet 1984
Acrylic paint on fibreboard and
cardboard
215 × 165 cm
Courtesy of the Froehlich Collection,
Stuttgart
Image: © The artist.
Courtesy of the Froehlich Collection,
Stuttgart
(Tate St Ives only)

Page 27
Blinky Palermo
Untitled 1969
Dyed fabric on undyed fabric
198.5 × 198.5 cm
Courtesy of Museum Kunstpalast,
Düsseldorf
Image: © The artist.
All rights reserved, DACS 2011.
Courtesy of Kunstpalast, Düsseldorf

Blinky Palermo
Blue Triangle 1966
(Blaues Dreieck)
Gouache paint on board
Triangular work:
B45 × L31.5 × R32.5 cm
Private Collection

Page 29
David Diao
3rd International/Tatlin 1985
Acrylic paint on canvas
269.2 × 132 cm
Courtesy of Postmasters Gallery,
New York
Image: © The artist.
Courtesy of Postmasters Gallery,
New York

Page 31
Martin Barré
65–S–9 1965
Spray paint on canvas
80 × 74 cm
Courtesy of Galerie Daniel Templon, Paris
Image: © Estate of Martin Barré. ADAGP,
Paris and DACS, London 2011.
Courtesy of Galerie Daniel Templon,
Paris

Martin Barré
65–A 1965
Spray paint on canvas
81 × 54 cm
Private collection, Paris

Martin Barré
63–Z 1963
Spray paint on canvas
81 × 54 cm
Private collection, Paris

Page 33
Michael Craig-Martin
Mirror Painting 1990–2011
Acrylic paint on aluminium panel
and mirror
228.6 × 129.5 × 29.8 cm
Courtesy of the artist
Image: © The artist

Page 35
Niele Toroni
*The Vertical Imprint of a No. 50
Brush Repeated at Regular Intervals
of 30 cm* 1988
*(Empreintes de Pinceau No. 50
Répétées à Intervalles Réguliers de
30 cm)*
Acrylic paint on canvas
200 × 200 cm
Collection FRAC Limousin, France
Image: © The artist.
Courtesy of Collection FRAC Limousin,
France

Page 37
Daniel Buren
One of the Possibilities 1973
*(L'une des Possibles Présentations
d'une Peinture/Sculpture de 1973)*
Paint on dyed canvas
90 × 1600 cm
Tate
Presented by Tate International
Council 2007
Image: *L'une des possibles
présentations d'une peinture /
sculpture de 1973*, exhibition
installation at Ghislain Mollet-Viéville,
Paris 1984. Detail.
© The artist.
ADAGP, Paris and DACS, London 2011.
Courtesy of Lisson Gallery, London

Page 39
David Reed
Untitled (No 45) 1974
Oil and acrylic paint on canvas
193 × 56.3 cm
Mondstudio Collection, on loan to
Kunstmuseum Bonn
Image: © The artist.
ARS, NY and DACS, London 2011.
Courtesy of Kunstmuseum, Bonn

Page 41
Jacob Kassay
Untitled 2009
Acrylic paint and silver on canvas
122 × 91.5 cm
Courtesy, the artist and Art: Concept,
Paris
Image: © The artist.
Courtesy of Art: Concept, Paris

Page 43
Sherrie Levine
Melt Down (After Yves Klein) 1991
Oil paint on wood
Each: 71.5 × 53 cm
Mondstudio Collection
Image: © The artist.
Courtesy of Mondstudio Collection

Page 45
Richard Tuttle
Paris Piece 1 1990
Wood, paint, collage and vinyl
137 × 97 × 16 cm
Collection FRAC Auvergne, France
Image: © The artist.
Courtesy of Collection FRAC
Auvergne, France

Page 47
Tomma Abts
Thiale 2004
Acrylic paint and oil paint on canvas
48 × 38 cm
Courtesy of greengrassi, London
Image: © The artist.
Courtesy of greengrassi, London

Page 49
André Cadere
Round Bar of Wood 1973
(Barre de Bois Rond)
Painted wood
155 × 3 cm
Tate
Purchased 2006
Image: © The artist

Page 51
Bob Law
A Cross for Me and a Cross for You
2003
Coach paint on canvas
25.5 × 35.5 cm
Estate of the artist, courtesy
Richard Saltoun, London
Image: © Estate of the artist.
Courtesy Richard Saltoun, London

Bob Law
*A Kiss for You, Broken Double
Cross for Me* 2003
Coach paint on canvas
25.5 × 35.5 cm
Estate of the artist, courtesy
Richard Saltoun, London

Bob Law
Two Crosses 2003
Coach paint on canvas
25.5 × 35.5 cm
Estate of the artist, courtesy
Richard Saltoun, London

Bob Law
Splitting a Double Cross 2003
Coach paint on canvas
25.5 × 35.5 cm
Estate of the artist, courtesy
Richard Saltoun, London

Page 53
Francis Baudevin
The Only Truth 2010
Acrylic paint on wall
Dimensions variable
Courtesy of the artist and
Gallerie Mark Müller, Zürich
Image: © The artist.
Courtesy of Art: Concept, Paris
(Mead Gallery only)

Francis Baudevin
Eyjafjallajoekull 2011
Acrylic paint on wall
Dimensions variable
Courtesy of the artist and
Gallerie Mark Müller, Zürich
(Tate St Ives only)

Page 55
Frank Stella
Hyena Stomp 1962
Oil paint on canvas
198.2 × 198.1 cm
Tate
Purchased 1965
Image: © ARS, NY and DACS,
London 2011

Page 57
Karin Davie
Symptomania 7 2008
Oil paint on canvas
182.9 × 243.8 cm
Courtesy the artist
Image: © The artist

John M Armleder
Brillian Xanthinus Arborescens 2008
Mixed media on canvas
300 × 200 cm
Courtesy Galerie Andrea Caratsch,
Zurich
(Mead Gallery only)

John M Armleder
John M Armleder
a commissioned exhibition with
Newlyn Art Gallery
8 October 2011 – 3 January 2012
Courtesy Galerie Andrea Caratsch,
Zürich and Simon Lee Gallery,
London
(Newlyn Art Gallery only)

Page 61
Peter Davies
Small Touching Squares Painting 1998
Acrylic paint and pencil on canvas
254.2 × 457.2 cm
Tate
Presented by the Patrons of New Art
(Special Purchase Fund) through
the Tate Gallery Foundation 1998
Image: © The artist

Page 63
Katharina Grosse
Untitled 2011
Acrylic paint on wall and window
Dimensions variable
Courtesy of the artist
Image: © The artist.
All rights reserved, DACS 2011
(Tate St Ives only)

Katharina Grosse
Untitled 2011
Acrylic paint on canvas
214 × 147 cm
Courtesy of the artist and
VG Bild-Kunst, Bonn

Page 65
Mary Heilmann
Pink Sliding Square 1978
Acrylic paint and latex on canvas
60.3 × 60.3 cm
Private Collection
Image: © The artist

Mary Heilmann
Primalon Ballroom 2002
Oil paint on canvas on wood
127 × 101.6 cm
Courtesy of Kenny Schachter

Mary Heilmann
Club Chair 62 2009
Stained wood with webbing
84.5 × 63.5 × 67.3 cm
Collection of the artist, courtesy of
Hauser and Wirth and 303 Gallery,
New York

Mary Heilmann
Club Chair 63 2009
Stained wood with webbing
84.5 × 63.5 × 67.3 cm
Collection of the artist, courtesy of
Hauser and Wirth and 303 Gallery,
New York

Page 67
Keith Coventry
England 1938 (1994–2011) 2011
Gloss paint on wood
274.3 × 76.2 cm per panel
Courtesy of the artist
Image: © The artist.
All rights reserved, DACS 2011

Page 69
Gene Davis
Popsicle 1969
Acrylic paint on canvas
165.1 × 165.1 cm
Private Collection
Image: © Estate of the artist.
All rights reserved, DACS 2011

Homage to Gene Davis
Franklin's Footpath 1972/2012
Road Installation
Dimensions variable
Courtesy of the artist's estate and the
Smithsonian Institution, Washington DC
(Mead Gallery only)

Page 71
Peter Young
#16–1968 (Dot Painting) 1968
Acrylic paint on canvas
168 × 198.5 cm
Courtesy of Kunstmuseum St.Gallen,
formal collection of Rolf Ricke
Image: © The artist.
Courtesy of Kunstmuseum St.Gallen,
formal collection of Rolf Ricke

Peter Young
Beads 1969
Acrylic
Each: 35 cm
Courtesy of Forum für
Internationale Kunst, Aachen

Page 73
Ingrid Calame
*Step on a Crack, Break your
Mother's Back* 2009
Oil paint on aluminium
101.6 × 61 cm
Courtesy of the artist, Frith Street
Gallery, London and James Cohen
Gallery, New York
© The artist.
Courtesy James Cohan Gallery,
New York/Shanghai

Page 75
Peter Halley
*Two Cells with Conduit and
Underground Chamber* 1983
Acrylic paint and Roll-a-Tex on canvas
177.8 × 203.2 cm
Collection of B.Z. and Michael Schwartz,
New York
Image: © The artist

Page 77
Richard Kirwan
Depth of Field 2011
Acrylic paint on canvas
168.2 × 137.7 cm
Courtesy the artist
Image: © The artist

Page 79
Tim Head
Continuous Electronic Surveillance
1989
Acrylic paint on canvas
198 × 320 cm
Collection of the artist
Image: © The artist

Page 81
Alex Hubbard
Horse Camp No.1 2010
Acrylic paint, enamel paint, resin
and fibreglass on canvas
193 × 153 cm
Atli Foundation, courtesy Simon Lee
Gallery, London
Image: © The artist.
Courtesy of Simon Lee Gallery, London

Page 83
Jeremy Moon
No. 5/73 1973
Oil paint on canvas
153 × 71.1 cm
Tate
Purchased 1974
Image: © The Estate of Jeremy Moon.
Courtesy Rocket Gallery, London

Page 85
Andy Warhol
Eggs 1982
Acrylic paint and silkscreen on canvas
228.6 × 177.8 cm
Courtesy of The Andy Warhol Museum,
Pittsburgh; Founding Collection,
Contribution The Andy Warhol
Foundation for the Visual Arts, Inc.
Image: © The Andy Warhol Foundation
for the Visual Arts, Inc./ARS, NY and
DACS, London 2011

Page 87
Tauba Auerbach
Untitled (Fold) 2011
Acrylic paint on canvas
152.4 × 114.3 cm
Collection of Sascha S. Bauer
Image: © The artist.
Courtesy of Paula Cooper Gallery,
New York

Page 89
Moira Dryer
The Vanishing Self-Portrait 1990
Acrylic paint on wood, on tree stump
198.1 × 218.4 cm
Collection of Hilary Cooper
Image: © Estate of Moira Dryer.
Courtesy of Collection of Hilary Cooper

Page 91
Michelle Grabner
Big Square Weave 1998
Enamel paint on board
84 × 84 cm
Courtesy Jonathan Stephenson,
Rocket Gallery, London
Image: © Paul Tucker/Courtesy Rocket
Gallery, London

Page 93
Olivier Mosset
Yellow blp 1987
Acrylic paint on canvas
280 × 140 cm
Courtesy Collection FRAC Limousin,
France
Image: © The artist.
Courtesy of Collection FRAC Limousin,
France

Page 95
Carl Ostendarp
Open at the Poles 1991
Foam and oil paint on canvas
165.1 × 180.3 cm
Courtesy the artist and Elizabeth Dee,
New York
Image: © The artist.
Courtesy of the artist and Elizabeth Dee,
New York

Page 97
Steven Parrino
Untitled 1992
Spray paint on canvas
92 × 92 cm
Collection Haus Konstruktiv, Zürich
Permanent loan for the
Mondstudio Collection
Image: © The Estate of Steven Parrino.
Courtesy of Haus Konstruktiv, Zürich

Page 99
Bernard Frize
Suite Segond 100 No 3 1980
Household paint on canvas
130 × 162 cm
Collection the artist, courtesy
Simon Lee Gallery, London
© The artist.
Courtesy of Simon Lee Gallery,
London.

Page 101
Ruth Root
Untitled 2004
Enamel paint on aluminium
121.9 × 106.7 cm
Courtesy of The Saatchi Gallery,
London
© The artist.
Courtesy of Maureen Paley, London
and The Saatchi Gallery, London

Page 103
Cheyney Thompson
Chromochrome set 3 2010
Oil paint on canvas
190.5 × 330 cm
Private Collection, Rome and
Campoli Presti, London / Paris
© The artist

Page 105
Bridget Riley
Cantus Firmus 1972–3
Acrylic paint on canvas
241.3 × 215.9 cm
Tate
Purchased 1974
© 2006 Bridget Riley.
All rights reserved

Page 107
Sean Scully
East Coast Light 2 1973
Acrylic paint on canvas
215 × 243.8 cm
Private Collection
© The artist.
All rights reserved, DACS 2011

Page 109
Jane Harris
Flirt 2009
Oil paint on canvas
107 × 123 cm
Courtesy of the artist and
Hales Gallery, London
© The artist.
Courtesy of the artist
and Hales Gallery, London

Page 111
Dan Walsh
Auditorium 2008
Acrylic paint on canvas
140 × 228 cm
Courtesy of The Saatchi Gallery,
London
© The artist

Page 113
Daniel Sturgis
No Other Home 2011
Acrylic paint on canvas
128 × 213 cm
Courtesy of the artist and Galerie
Hollenbach, Germany
© The artist

Page 115
Heimo Zobernig
Untitled 2008
Acrylic paint and tape on canvas
150 × 150 cm
Courtesy Simon Lee Gallery, London
© The artist.
All rights reserved, DACS 2011.
Courtesy of Simon Lee Gallery,
London

Authors' biographies

Alison Green
Is an art historian, curator and critic.
She lives and works in London.

Stephen Moonie
Is an art historian.
He lives and works in Newcastle-upon-Tyne.

Terry R Myers
Is an independent curator and educator.
He lives and works in Chicago and Los Angeles.

Bob Nickas
Is an independent curator and critic.
He lives and works in New York.

Daniel Sturgis
Is an artist.
He lives and works in London.

Acknowledgements

This exhibition has been developed and coordinated with the expertise of staff from both organisations.

For the Mead Gallery and Warwick Arts Centre
Julia Barry, Marketing Manager; Elizabeth Dooley, Assistant Curator (Art Collection); Richard Evans, Senior Finance Assistant; Alison Foden, Finance Manager; Emma O'Brien, Assistant Front of House Manager; Jan McQuillan, Press Officer; Brian McStay, Technician; Jane Morrow, Assistant Curator (Mead Gallery); Rebecca Richards, Gallery Front of House; Sarah Shalgosky, Curator; Nadia Wazera, Artist and Education Leader.

For Tate St Ives
Mark Osterfield, Excutive Director; Martin Clark, Artistic Director; Sara Matson and Miguel Amado, Curators; Matthew McDonald, Registrar; Holly Grange, Assistant Curator; Arwen Fitch, Press Officer; Jowdy Davey , Development Manager; Tressa Lapham-Green, Development Administrator; Susan Lamb, Head of Learning; Steven Paige, Research Assistant; Kerry Rice and Georgina Kennedy, Learning Curators; Dave Davies and Carey Harvey, Assistant Learning Curators with artist-educator and casual teams; Danielle Hitchcock, Marketing Officer; Simon Pollard, Building Manager; Philip Medley, Darrel Sherlock, Norman Pollard, Nick Brierley and Nick Sharp, Technicians; Fiona Cattrell, Directors' PA with Vicki Stevens, Sue Fishwick and Katie Lennon, Administrators; Zara Devereux, Visitor Services Manager and the Visitor Services team; Jan Evans, Membership Assistant and all our volunteers.

Our thanks to the Conservation and Registrarial teams in London, particularly Susan Breen, Katey-Mary Twitchett, Piers Townshend, Caroline McCarthy, Bronwyn Gardner and Alyson Rolington.

Photography credits

p.19 © Geoffrey Clements for Myron Stout
p.25 © Jochen Littkemann, Berlin for Imi Knoebel
p.33 © Tate. Samuel Drake, Lucy Dawkins/Tate
Photography for Michael Craig-Martin
p.35 © G. Gendeaud, Limoges for Neile Toroni
p.45 © K. Ignatiadis for Richard Tuttle
p.49 © Tate. Andrew Dunkley/Tate Photography for
André Cadere
p.53 © Conradin Frei for Francis Baudevin
p.63 © Art Evans for Katharina Grosse
p.65 © Etienne Frossard for Mary Heilmann
p.67 © Tate. Samuel Drake, Lucy Dawkins/Tate
Photography for Keith Coventry
p.69 © Brandon Webster for Gene Davis
p.77 © Peter White FXP Photography for Richard Kirwan
p.89 © Etienne Frossard for Moira Dryer
p.95 © Tom Powel for Carl Ostendarp
p.97 © A. Burger, Zürich for Steven Parrino
p.101 © Tate. Samuel Drake, Lucy Dawkins/Tate
Photography for Ruth Root
p.109 © Peter White FXP Photography for Jane Harris
p.113 © Peter White FXP Photography for Daniel Sturgis

First published 2011 by order of the Tate Trustees
by Tate St Ives and Mead Gallery, University of Warwick
in association with Tate Publishing, a division of
Tate Enterprises Ltd, Millbank, London SW1P 4RG
www.tate.org.uk/publishing

On the occasion of the exhibition
The Indiscipline of Painting—
International abstraction from the 1960s to now
Tate St Ives 8 October 2011–3 January 2012
(with John M Armleder at Newlyn Art Gallery)
Mead Gallery, Warwick Arts Centre
14 January –10 March 2012

Curated by Daniel Sturgis with Sarah Shalgosky and Martin Clark.

**The exhibition and publication have been
generously supported by:**
Arts Council England
The Henry Moore Foundation
The Higher Education Funding Council
Tate Members
Tate St Ives Members
Institut für Auslandsbeziehungen
Hibrow.tv

This exhibition has been made possible by the provision of
insurance through the Government Indemnity Scheme.
The Tate St Ives and Mead Gallery would like to thank
H M Government for providing Government Indemnity and the
Department for Culture, Media and Sport and the Museums,
Libraries and Archives Council for arranging the indemnity.

British Library Cataloguing in Publication Data: A catalogue
record for this book is available from the British Library

ISBN 978-1-84976-000-3

Texts by Martin Clark, Sarah Shalgosky, Daniel Sturgis,
Alison Green, Stephen Moonie, Bob Nickas and Terry R Myers.

Edited by Daniel Sturgis, Martin Clark and Sarah Shalgosky
Editorial Assistance by Holly Grange with Jane Morrow,
Sarah Derry and Sara Matson
Image acquisition and copyright by Jill Sheridan
and Arwen Fitch with Katie Lennon and Holly Grange
Design by Stefi Orazi studio
Printed by Pureprint Ltd

The publishers have made every effort to trace copyright
holders but apologise for any omissions that may have
inadvertently been made.

Measurements of artworks are given in centimetres,
height before width.

Front and back cover:
Peter Young *#16–1968 (Dot Painting)* 1968 (detail)
Acrylic paint on canvas
© The artist. Courtesy of Kunstmuseum St. Gallen,
formal collection of Rolf Ricke